For Immediate Release
Contact: Evelyn Lee
elee@prestel-usa.com
Tel: (212) 995-2720, Ext. 25
Fax: (212) 995-2733

Prestel

Elizabeth Heyert: The Travelers

Shot in a Harlem funeral parlor, Elizabeth Heyert's nearly life-size color photographs evolved from her fascination with the practice of some members of the Harlem community, people with traditional ties to their church and to their Southern roots, of elaborately dressing corpses for burial. No matter the circumstances of their life, or death, the departed are, in one undertaker's words, "going to the party"—jubilantly dressed in satin dresses, white suits, tuxedos, and magnificent hats, for their journey to paradise. Mesmerized by this gorgeous preparation ritual for greeting life after death, Heyert embarked on a project to photograph the beautifully coiffed and adorned bodies as if she were making formal portraits of living human beings. Heyert's portraits offer a provocative meditation on humanity, dignity, and death, while poignantly highlighting a fading funeral custom associated with the changing Harlem community.

"My portraits aren't about death, but about people's lives," says Heyert. "They're not unlike eulogies: these photographs are visual accounts of what the living want to remember, the stories we all want to tell about the dead." Taken with the permission of the funeral director, and written permission from the individual families involved, the 30-by-38 inch photographs are formal portraits rather than documents of bodies in coffins. Heyert employed a black cloth as a backdrop to conceal the casket and focus on the deceased. Perched on a tall ladder, she photographed her subjects from overhead using an 8 x 10 view camera and elaborate portrait lighting. By design Heyert's portraits challenge our perceptions of what it means to be human, and what it is we see when we look at the dead and the living. At first glance, her subjects often appear to be alive, merely caught in a reflective moment with their eyes gently closed.

Works in the series include images of people, ranging in age from 22 to 101 years, who died in Harlem in 2003 or 2004. The portrait of Daphne Jones, who passed away in 2003 at the age of 49, shows a woman as if peacefully sleeping, her hands in white lace gloves resting against the light-blue gown that covers her body. Nearly a year later Heyert photographed Jones's son, James Earl Jones, who is dressed in a new Sean John tracksuit and Timberland boots. He died in 2004 at the age of 22.

Captions that accompany the photos (stating name, the date and place of birth, and the date of death in Harlem) reveal that over half of Heyert's subjects were born in the American south—Georgia, the Carolinas, Virginia, Mississippi, and Tennessee. Taken together, the images and text provoke questions about the journey the people had on earth, in many cases virtually spanning the 20th century, as well as the one they were dressed to embark on.

Heyert has long been interested in portraiture—she is author of the 1979 book *The Glass-House Years: Victorian Portrait Photography 1839-1870*—and wanted to explore alternative forms of the genre in her own work. Her 2002 series "The Sleepers" features black-and-white portraits of people sleeping in the nude. (In 2003 the images were exhibited at Edwynn Houk and published in a book of the same title.) In "The Travelers", Heyert invites us to ruminate on the beauty and complexity of ordinary lives, once their full story has been told, as well as to witness a cultural history that is vanishing.

A selection of "The Travelers" has been exhibited at the Musée de l'Elysée in Switzerland and the Hayward Gallery in London. The works have also been the subject of a short feature by TVE Spain, a National Public Radio program, a feature article in the Swiss publication *Femina*, and a feature article in The New York Times.

About the Photographer:
Elizabeth Heyert is the author/photographer of *Metropolitan Places, The Artful Table, The Glass-House Years,* and *The Sleepers.*

About the Publisher:
Scalo is based in Zurich, Switzerland, and is distributed in North America by Prestel Publishing.

About the Book:

Title:	***Elizabeth Heyert: The Travelers***
ISBN:	3-908247-93-4
Price:	$65.00
Pages:	72
Illustrations:	32 in color
Trim size:	10 ¼ x 13
Pub Date:	May 2006

Please send two tearsheets upon review.

The Travelers

For Murray Heyert (1912–1998)
and Florence Heyert (1914–1999)

Elizabeth Heyert

The Travelers

Scalo

Daphne Jones
Born: August 1954
New York, New York
Died: October 2003
Harlem, New York

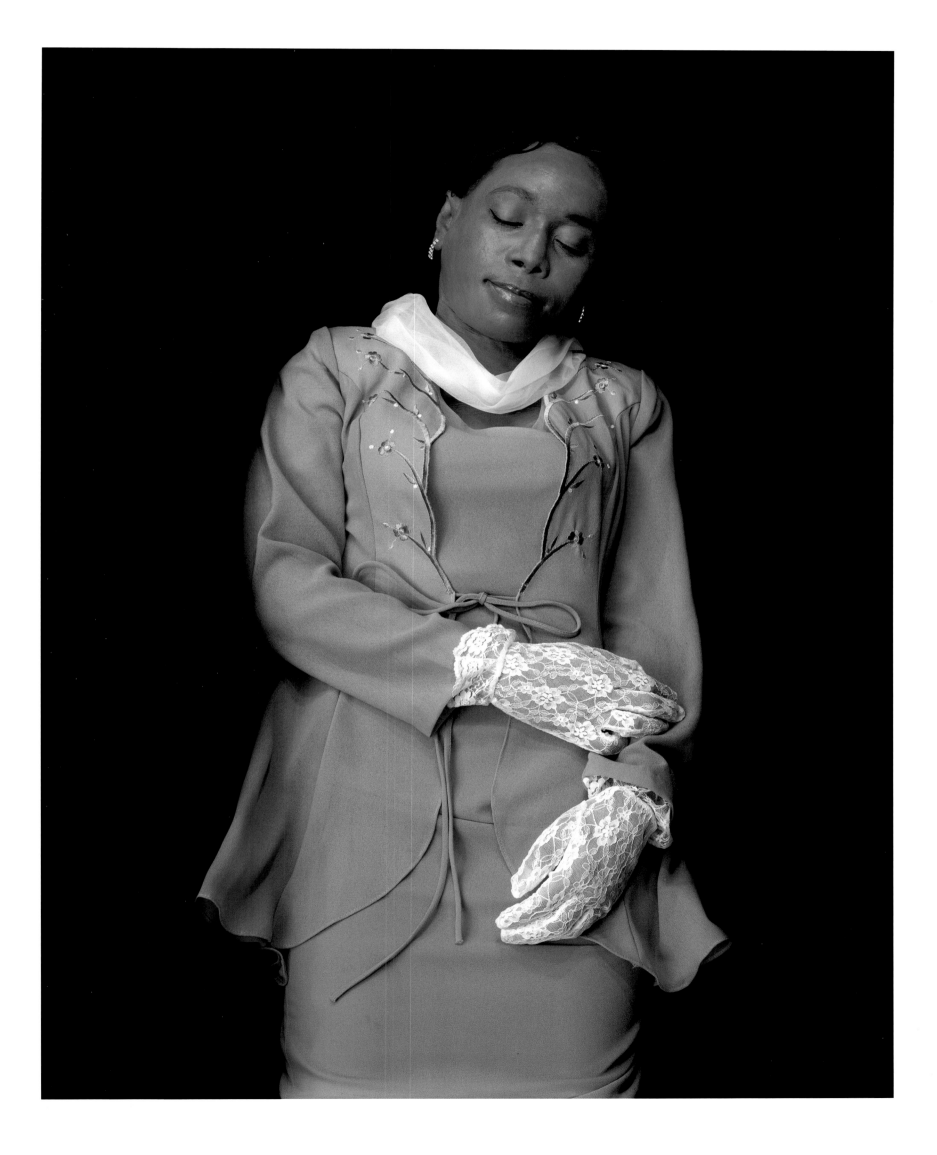

Raymond E. Jones Sr.
Born: December 1928
Memphis, Tennessee
Died: January 2004
Harlem, New York

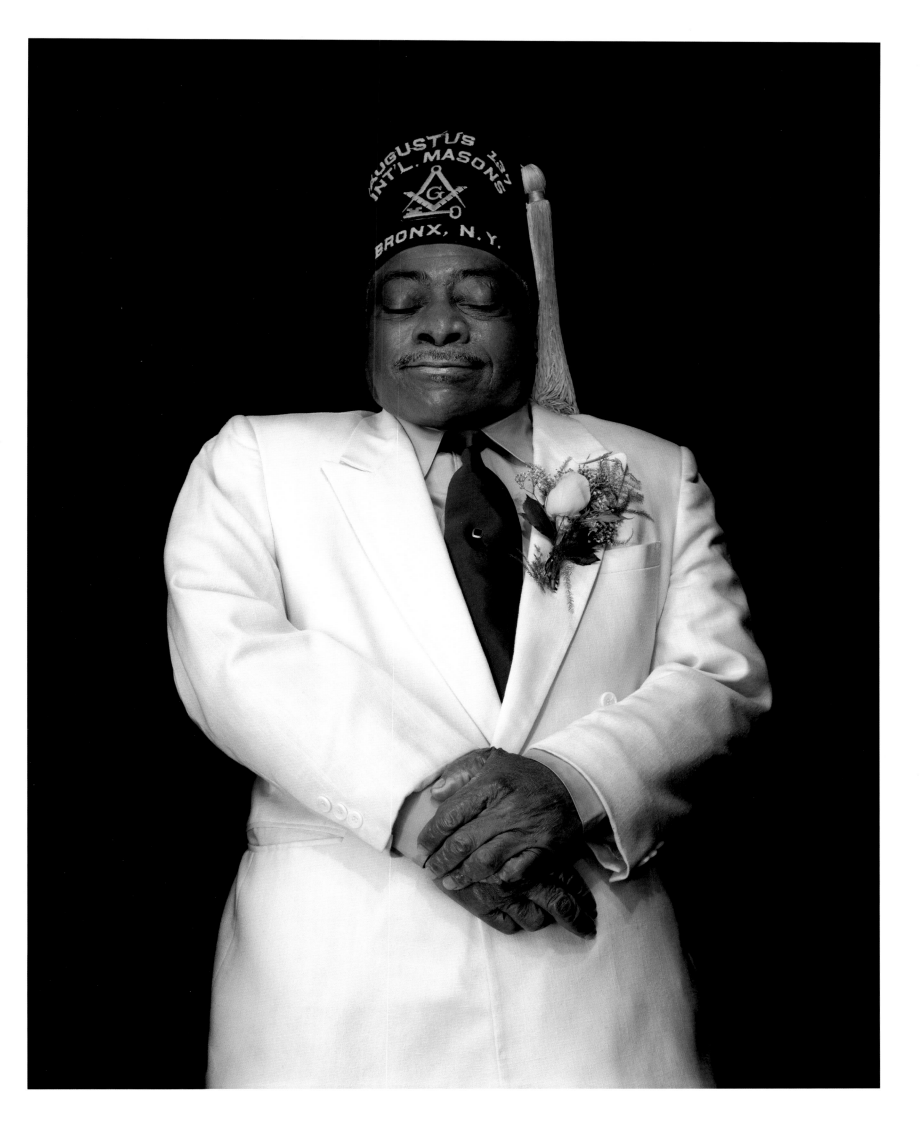

Rosie Inez Miller
Born: Unknown
Died: October 2003
Harlem, New York

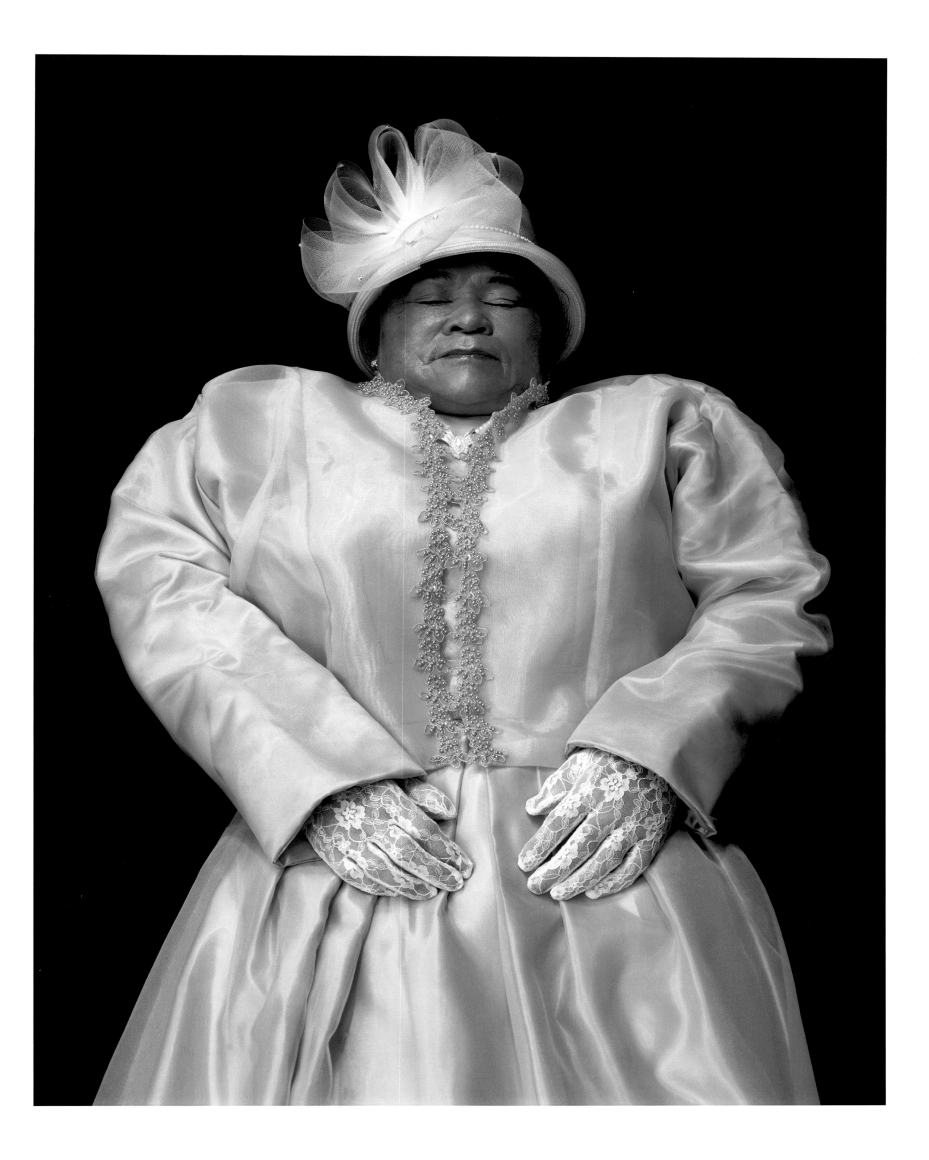

Lottie Fennell
Born: Unknown
Died: October 2003
Harlem, New York

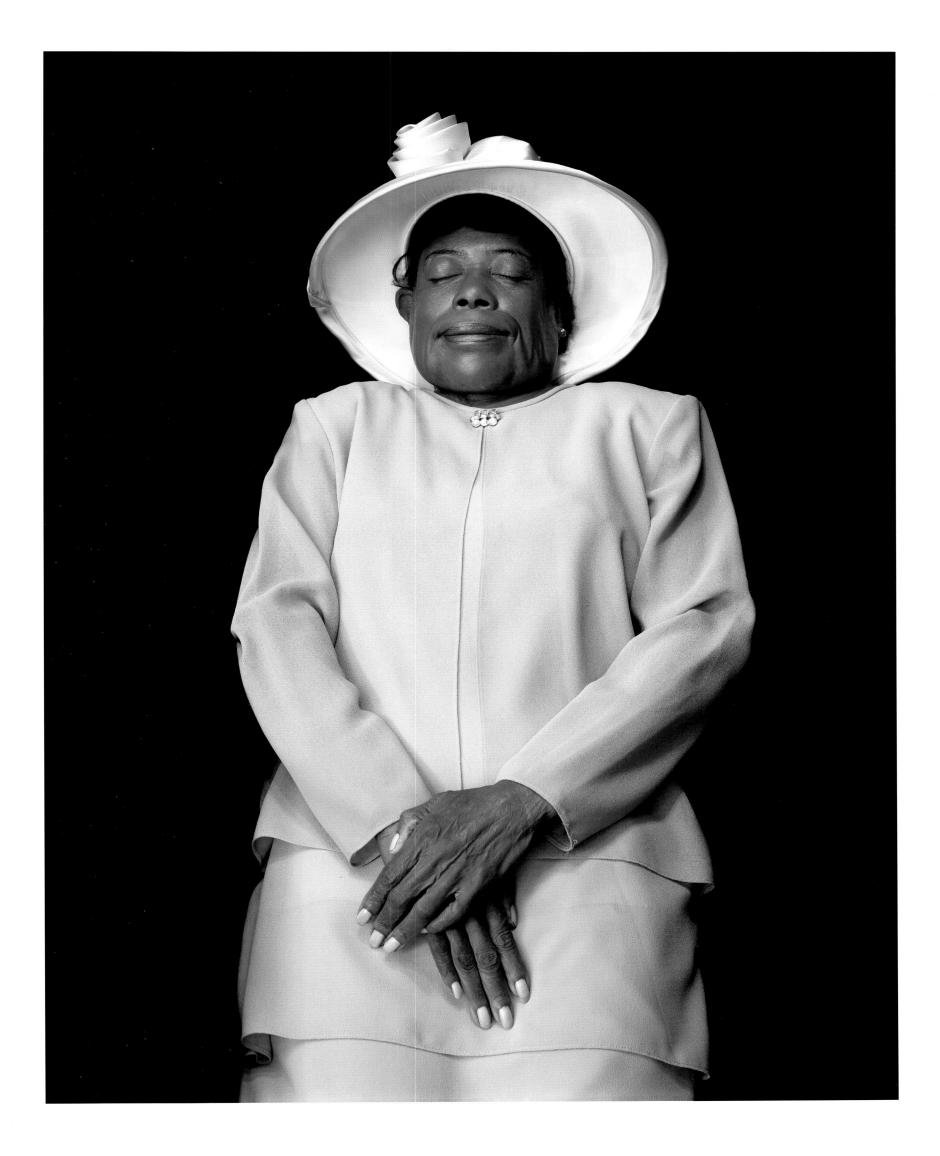

Daniel Rumph
Born: September 1933
Branchville, South Carolina
Died: September 2003
Harlem, New York

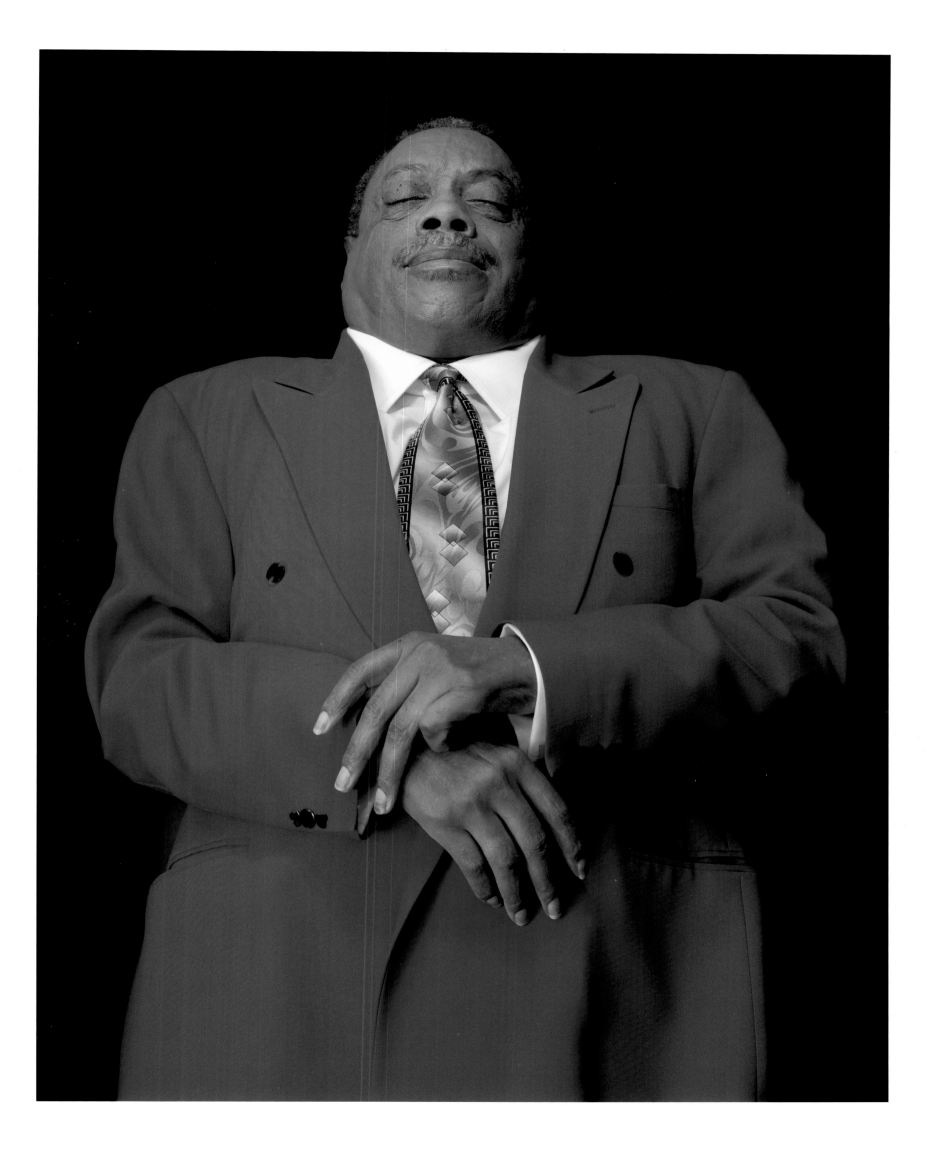

Myra Hanshaw
Born: August 1925
Aiken, South Carolina
Died: February 2004
Harlem, New York

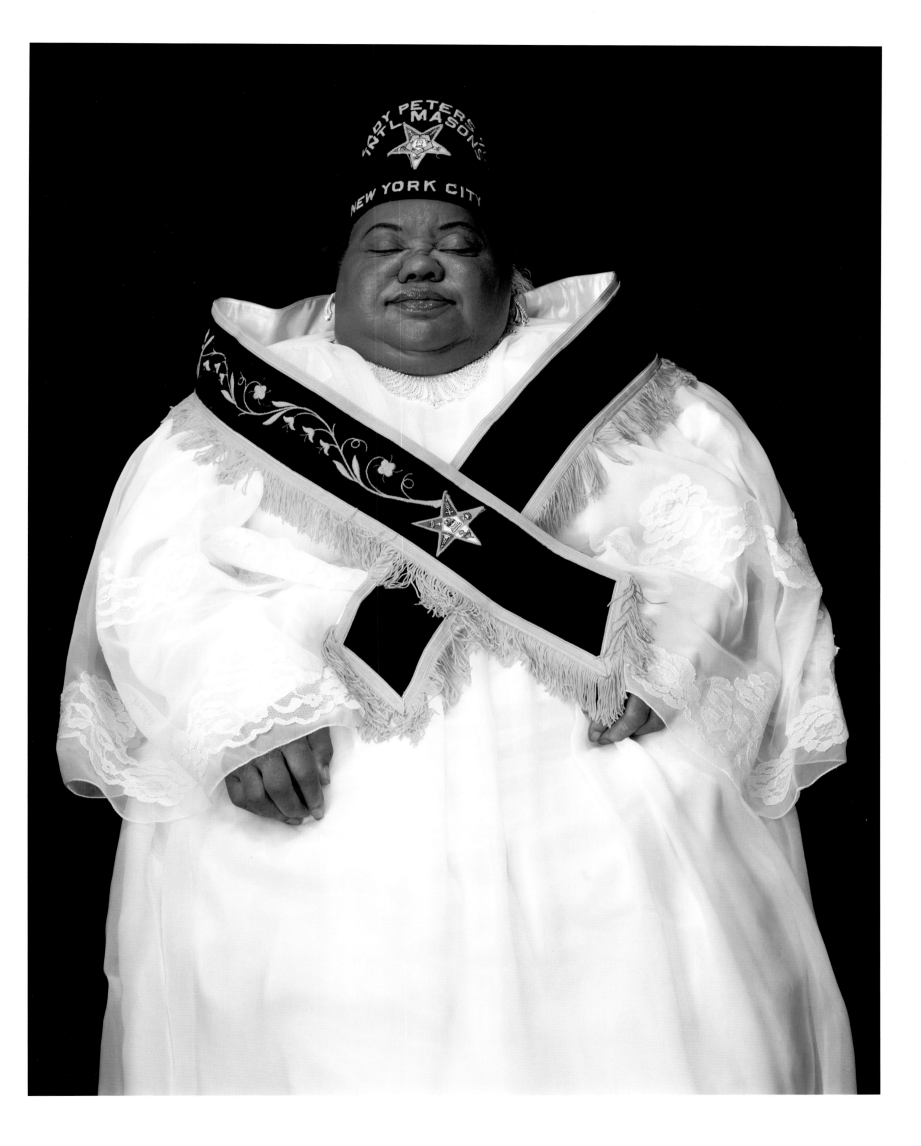

Preston Washington Sr.
Born: February 1924
New York, New York
Died: September 2003
Harlem, New York

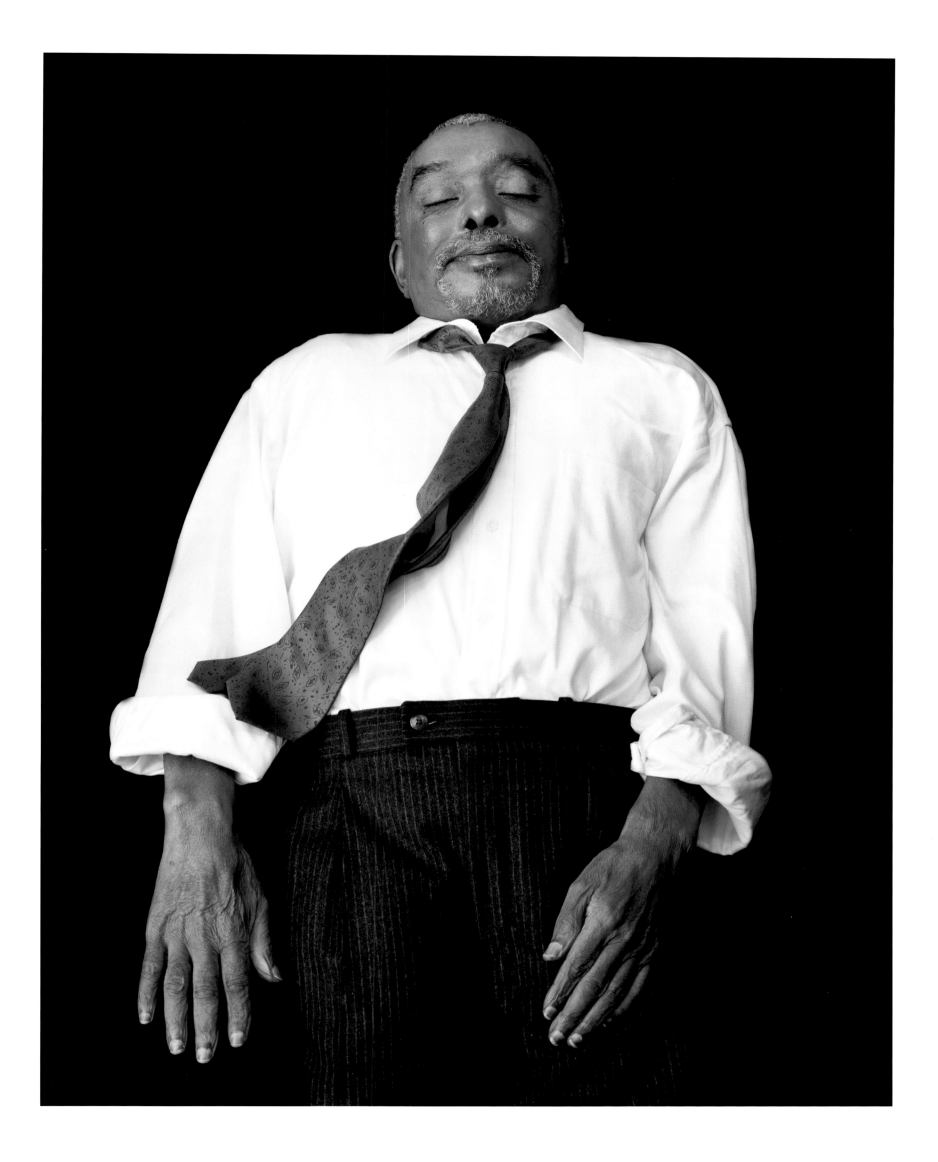

James "La Smoothe" Patterson Jr.
Born: September 1966
New York, New York
Died: February 2004
Harlem, New York

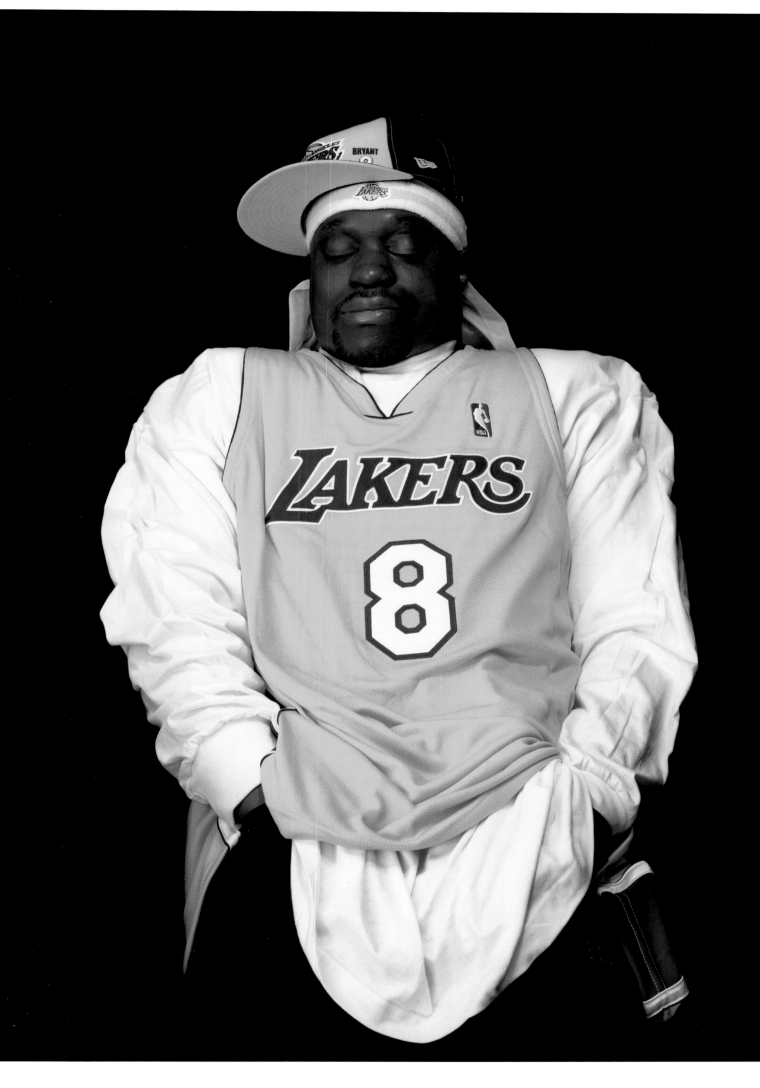

Lola B. Hopkins
Born: September 1922
Madison, Georgia
Died: January 2004
Harlem, New York

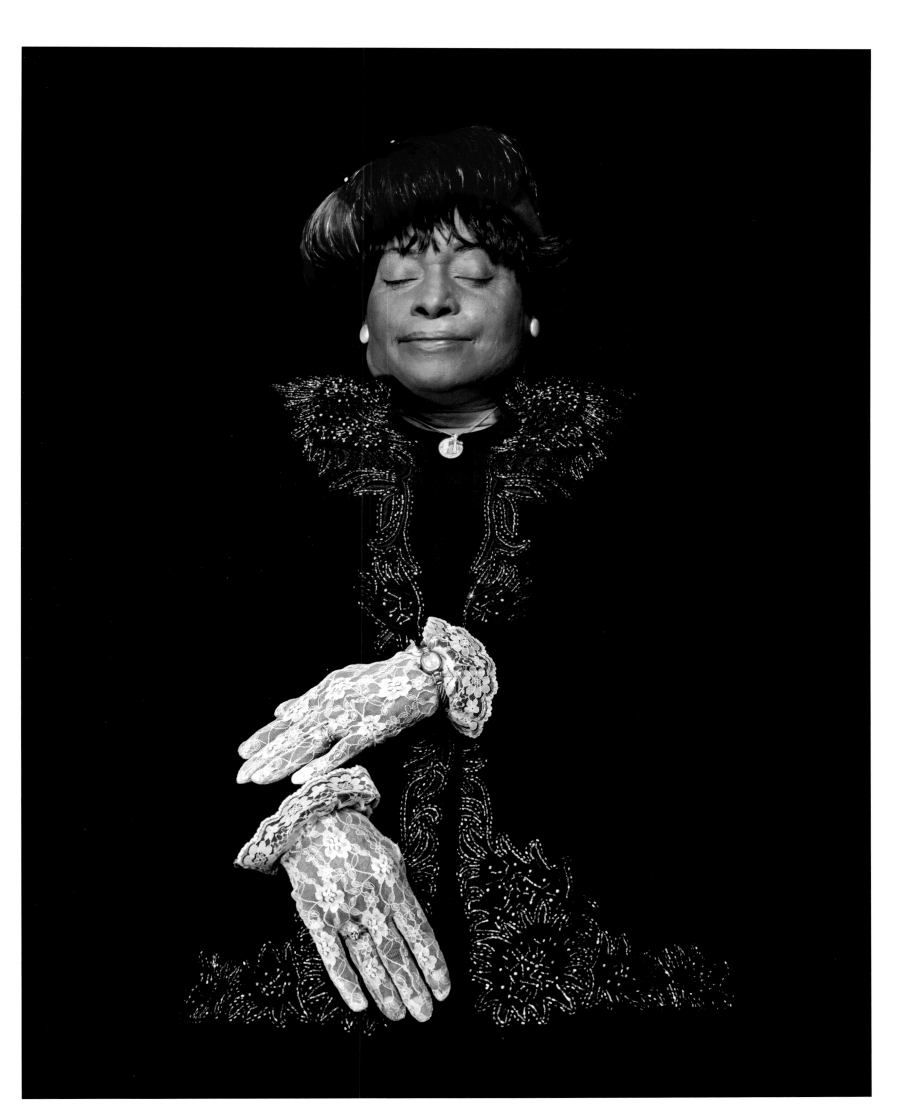

Anna Bell McGill
Born: February 1923
New York, New York
Died: March 2003
Harlem, New York

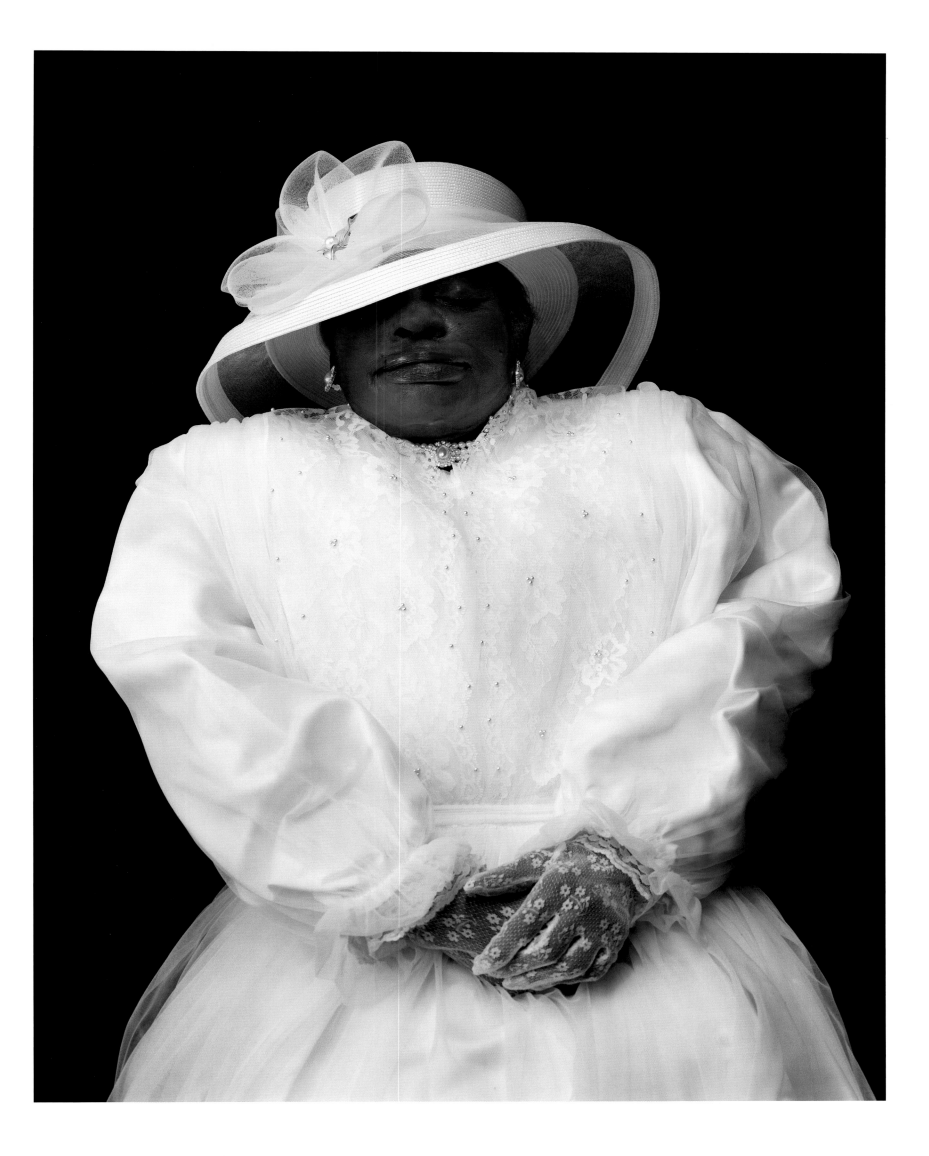

Martha Webb
Born: April 1941
Norfolk, Virginia
Died: January 2004
Harlem, New York

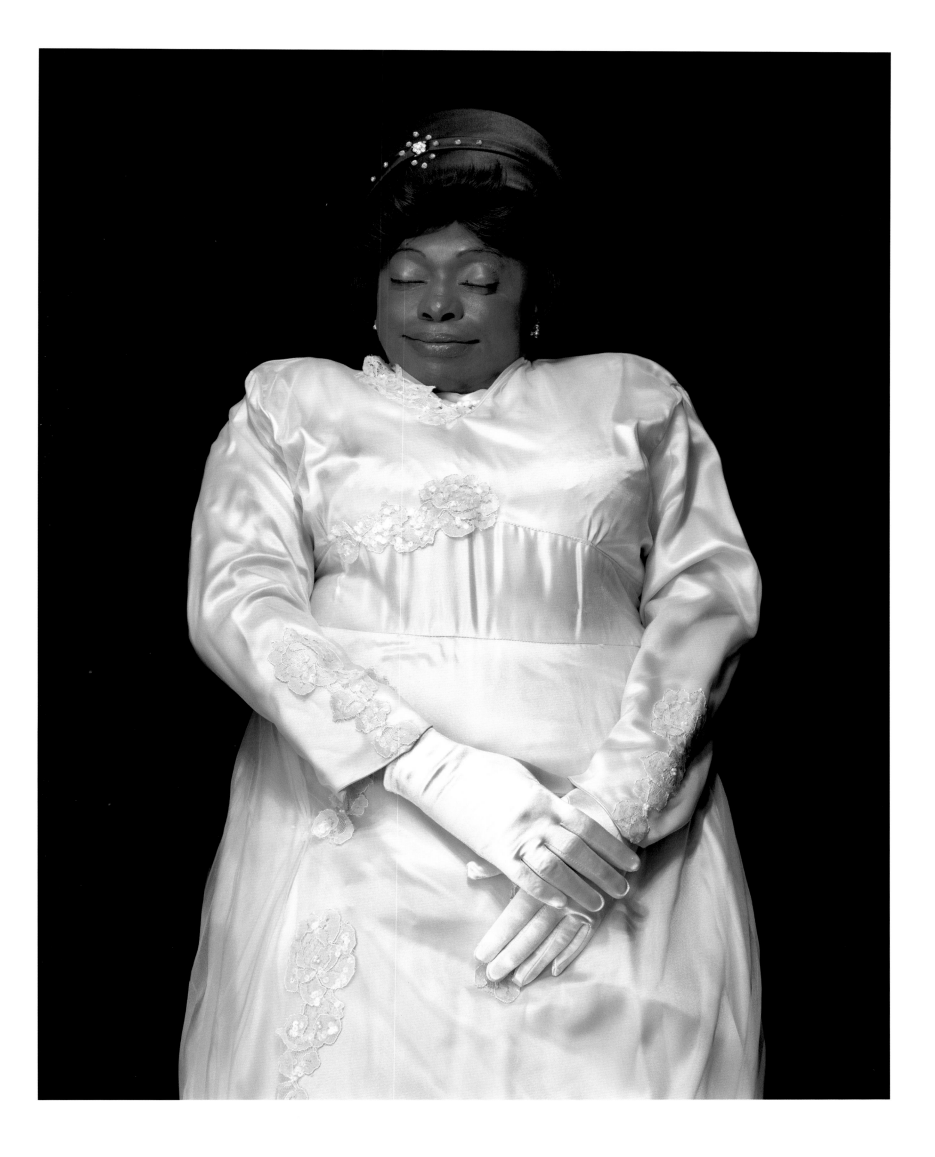

Mary Caparitia Bush
Born: December 1947
Trinidad, West Indies
Died: February 2004
Harlem, New York

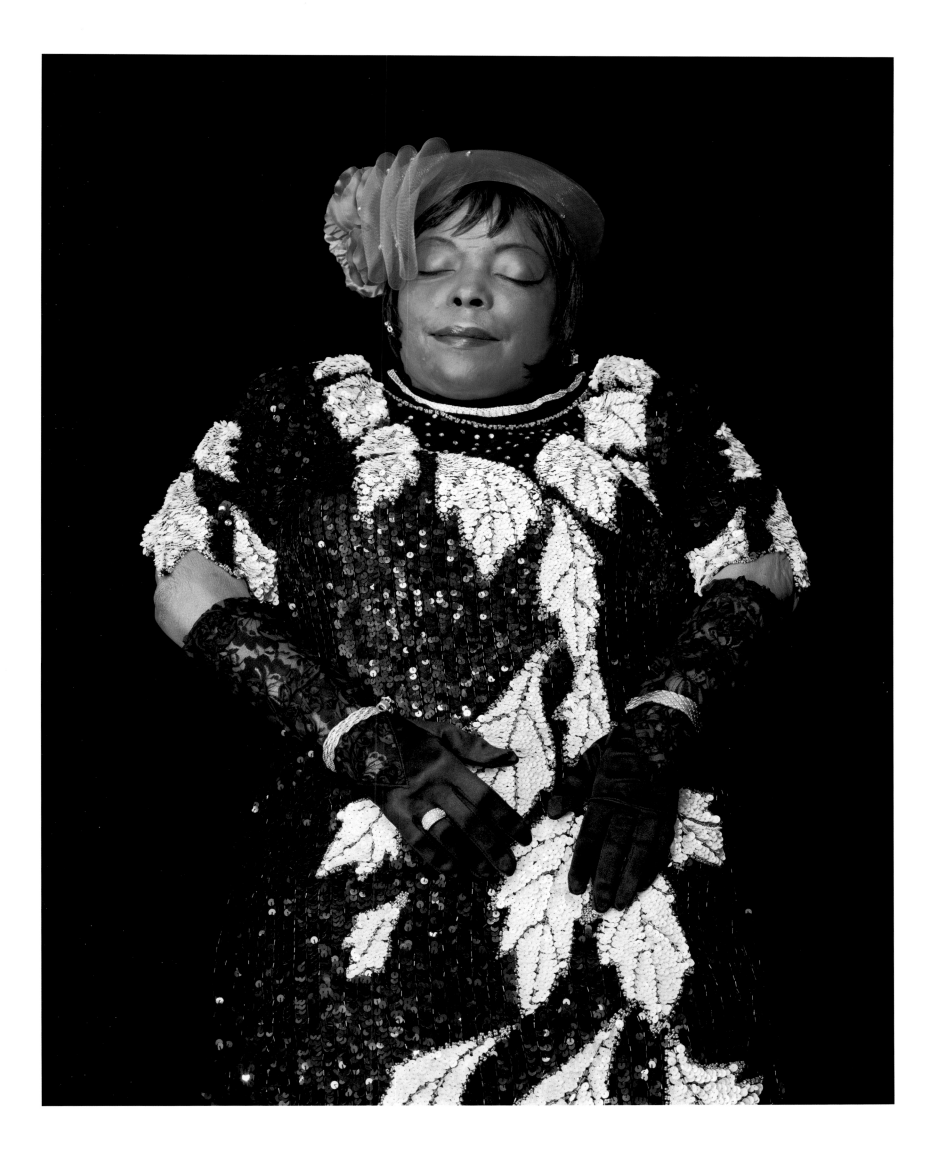

James Earl "Jay Moe" Jones
Born: February 1982
New York, New York
Died: March 2004
Harlem, New York

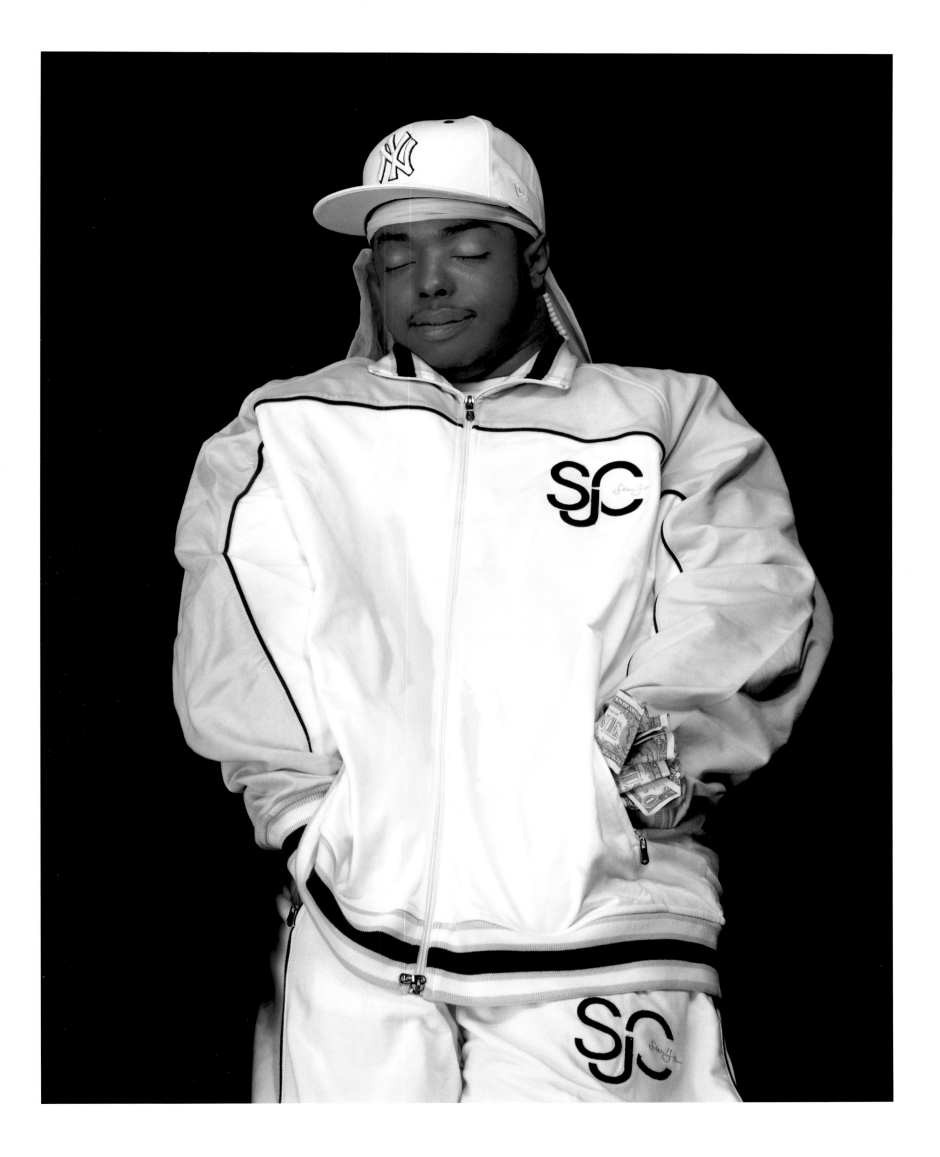

Preston Washington Jr.
Born: August 1946
New York, New York
Died: June 2003
Harlem, New York

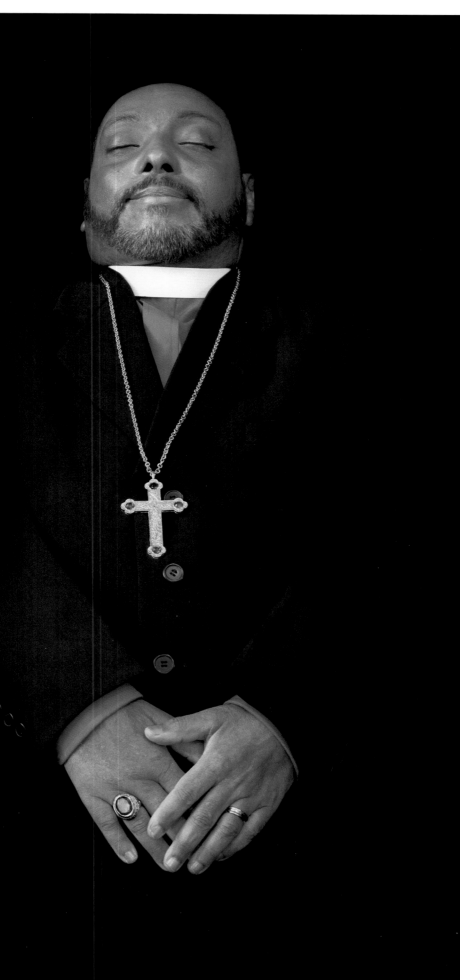

Nathalie Ames
Born: September 1951
Brooklyn, New York
Died: January 2004
Harlem, New York

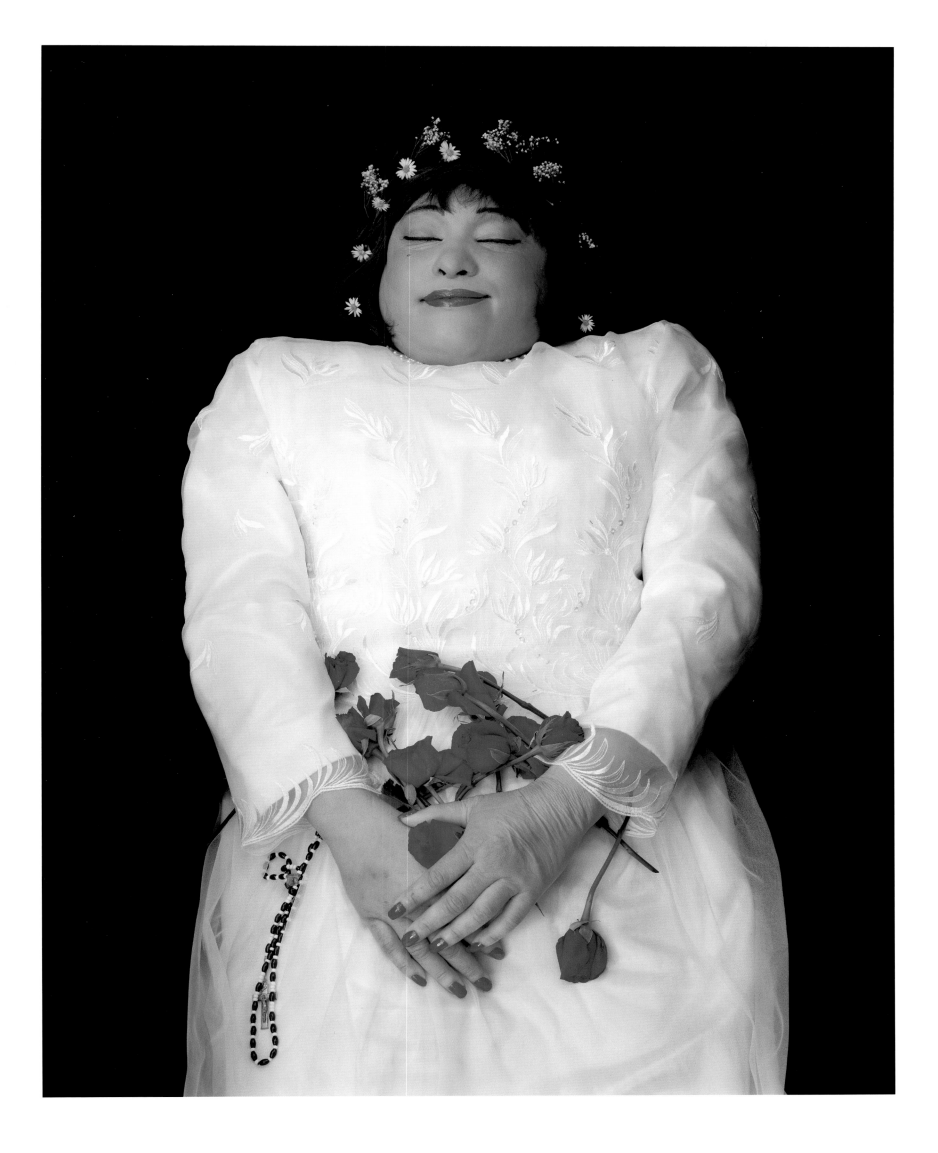

French Perry
Born: September 1924
Kittrel, North Carolina
Died: September 2003
Harlem, New York

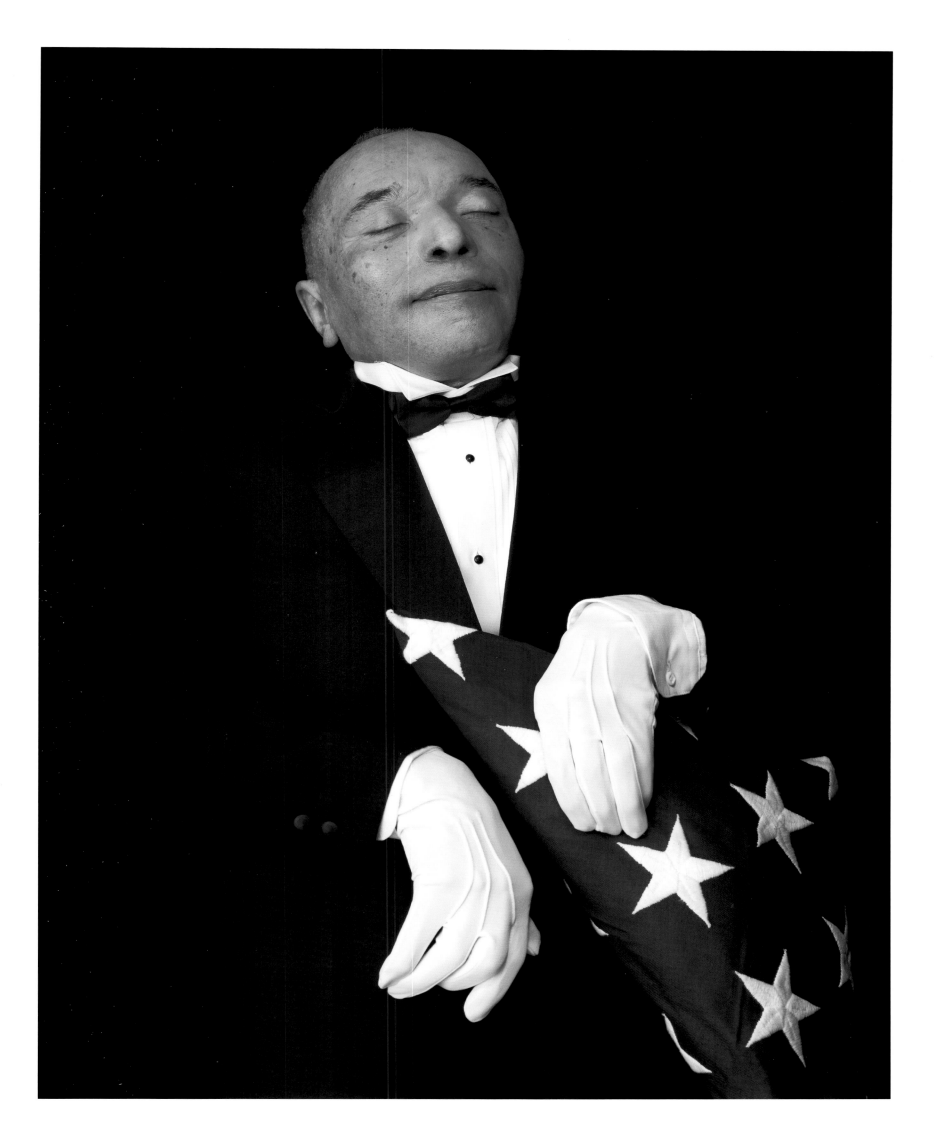

Lillian Susan Lloyd ("Mama Lloyd")
Born: January 1917
Camden, South Carolina
Died: May, 2003
Harlem, New York

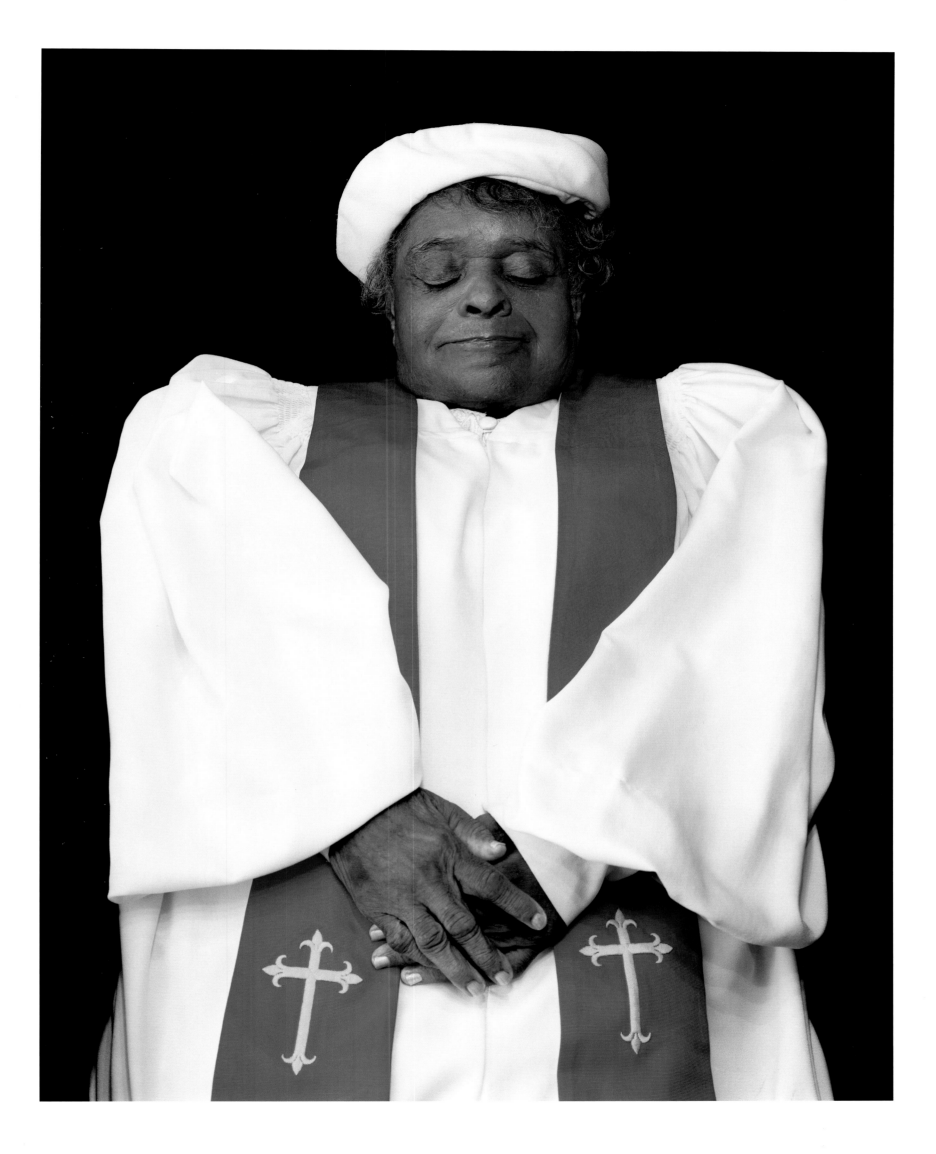

Mary Catherine Anderson
Born: June 1968
Holly Hills, South Carolina
Died: March 2003
Harlem, New York

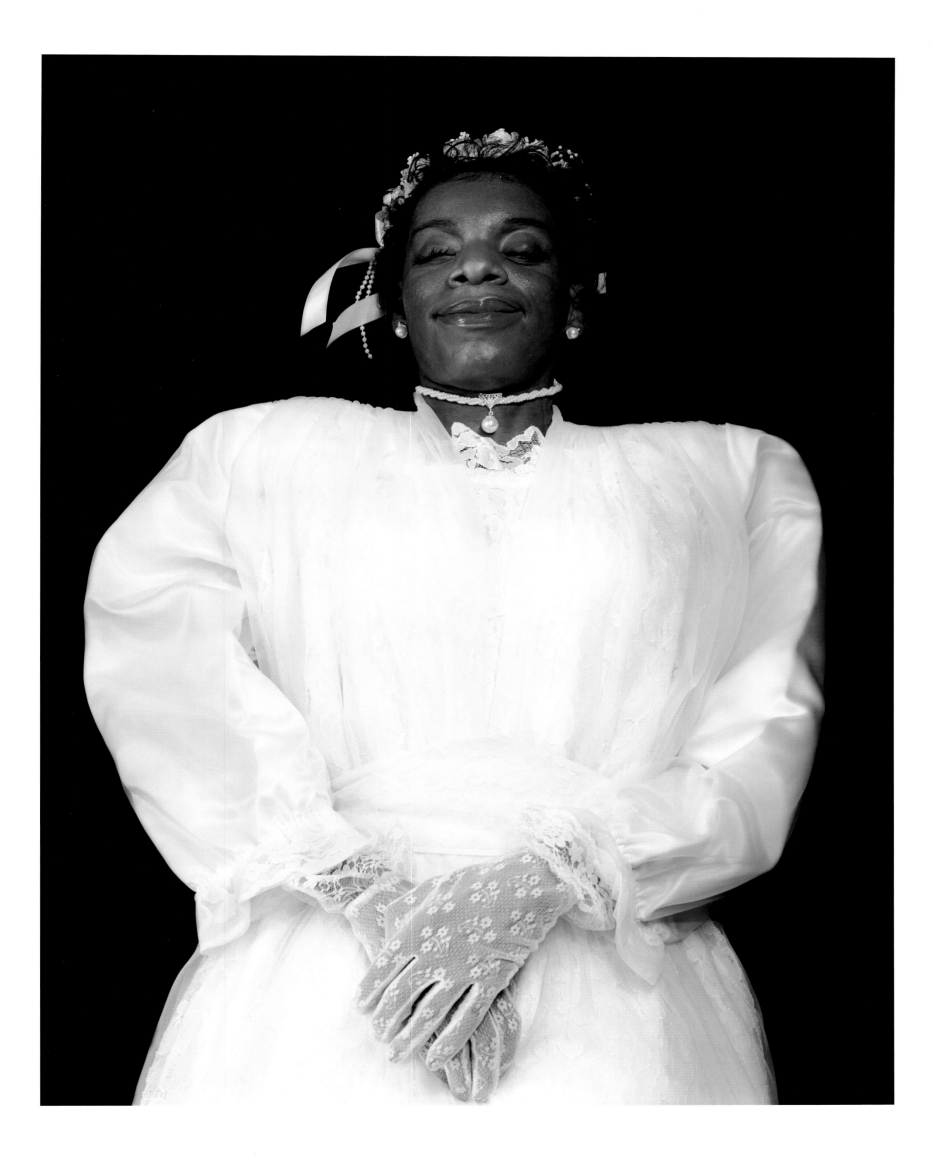

Minnie Lee Ancrum
Born: November 1926
Racetrack Plantation, Greenwood, Mississippi
Died: December 2003
Harlem, New York

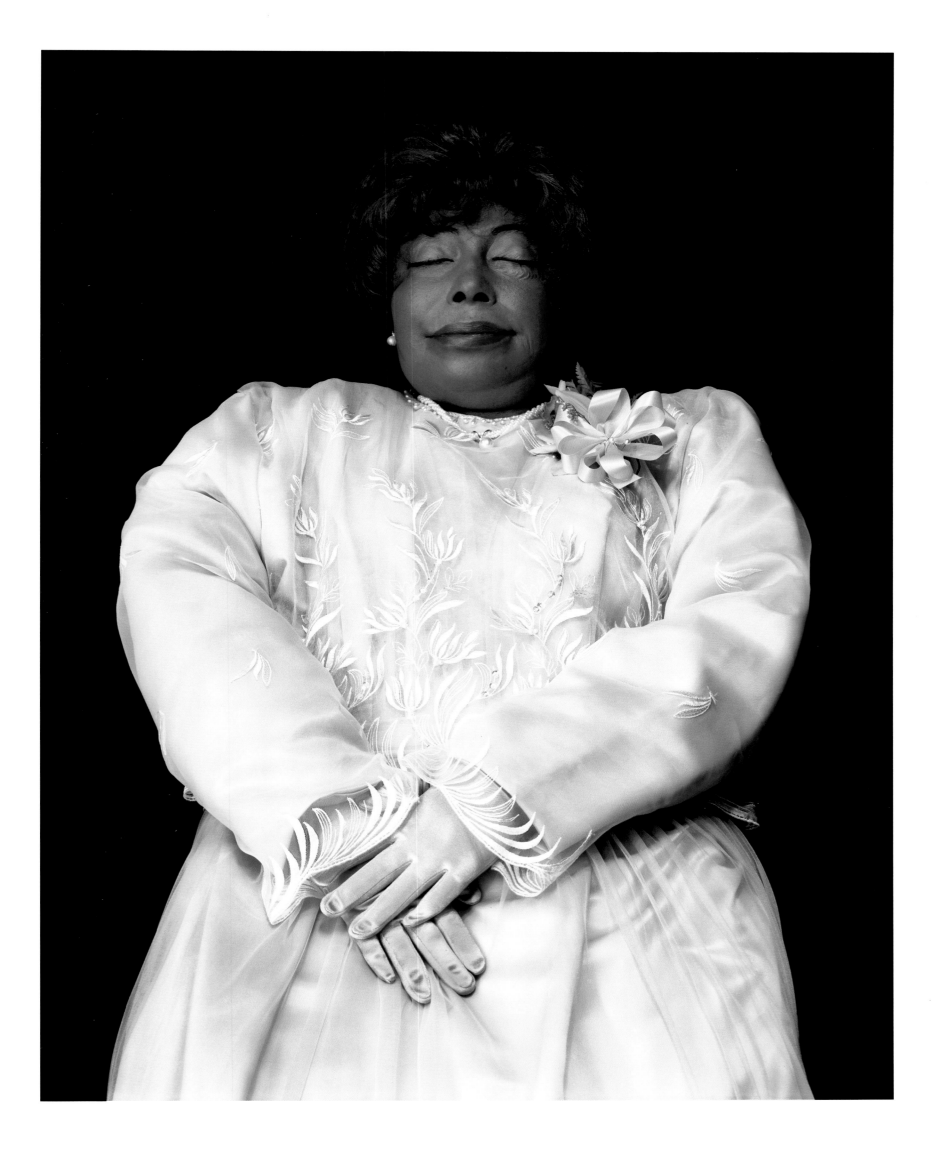

Irene Rahming
Born: September 1928
Georgetown, South Carolina
Died: November 2003
Harlem, New York

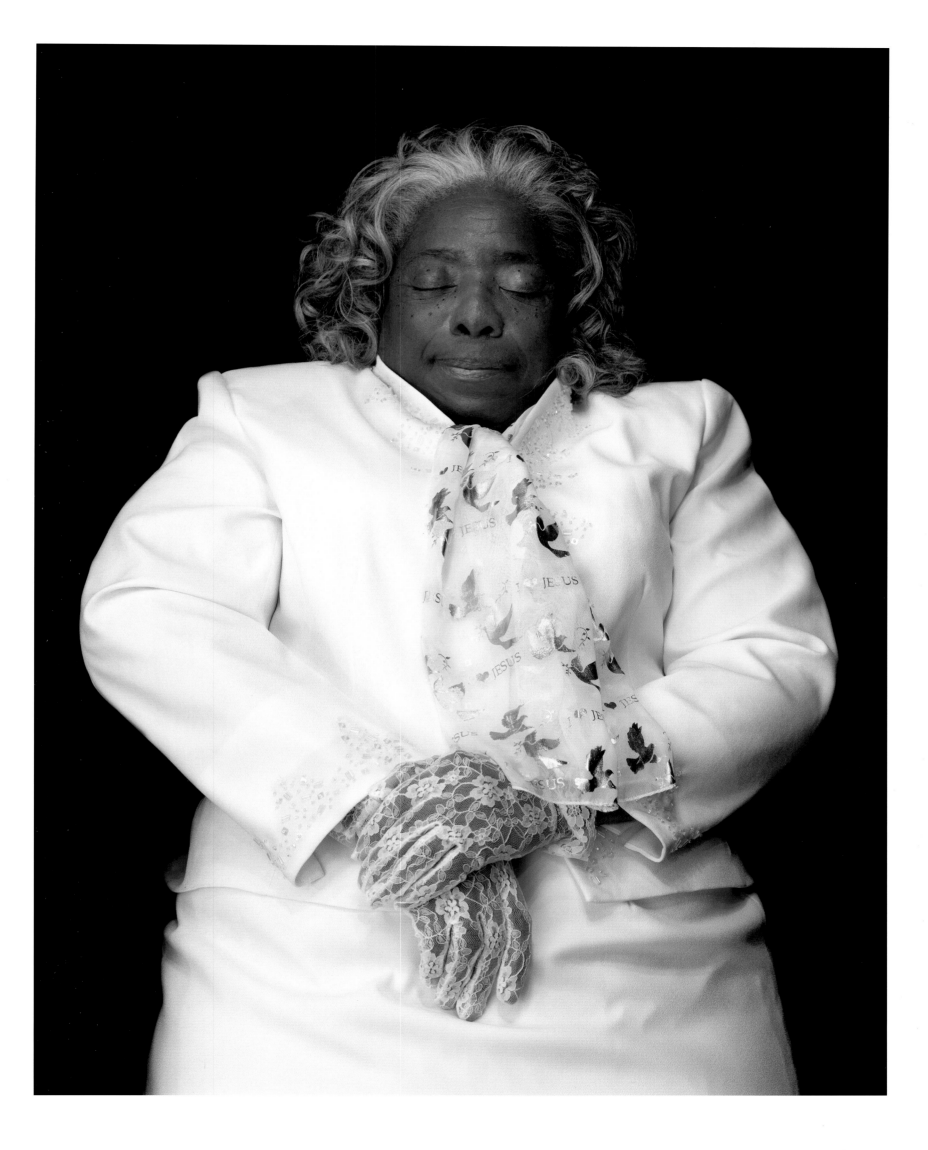

Rosalie Thompson Thomason
Born: October 1922
Winnsboro, South Carolina
Died: June 2003
Harlem, New York

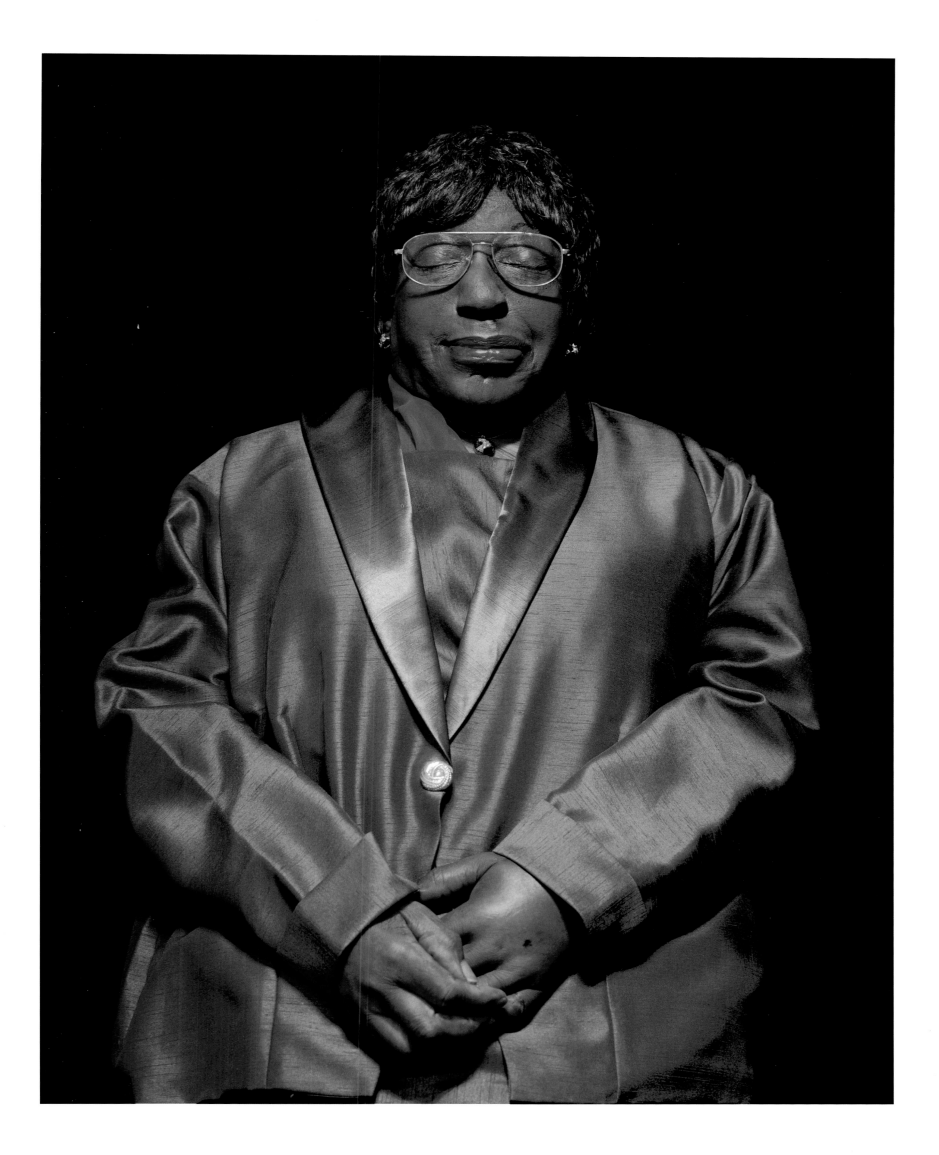

Beatrice Samuels
Born: Unknown
Died: October 2003
Harlem, New York

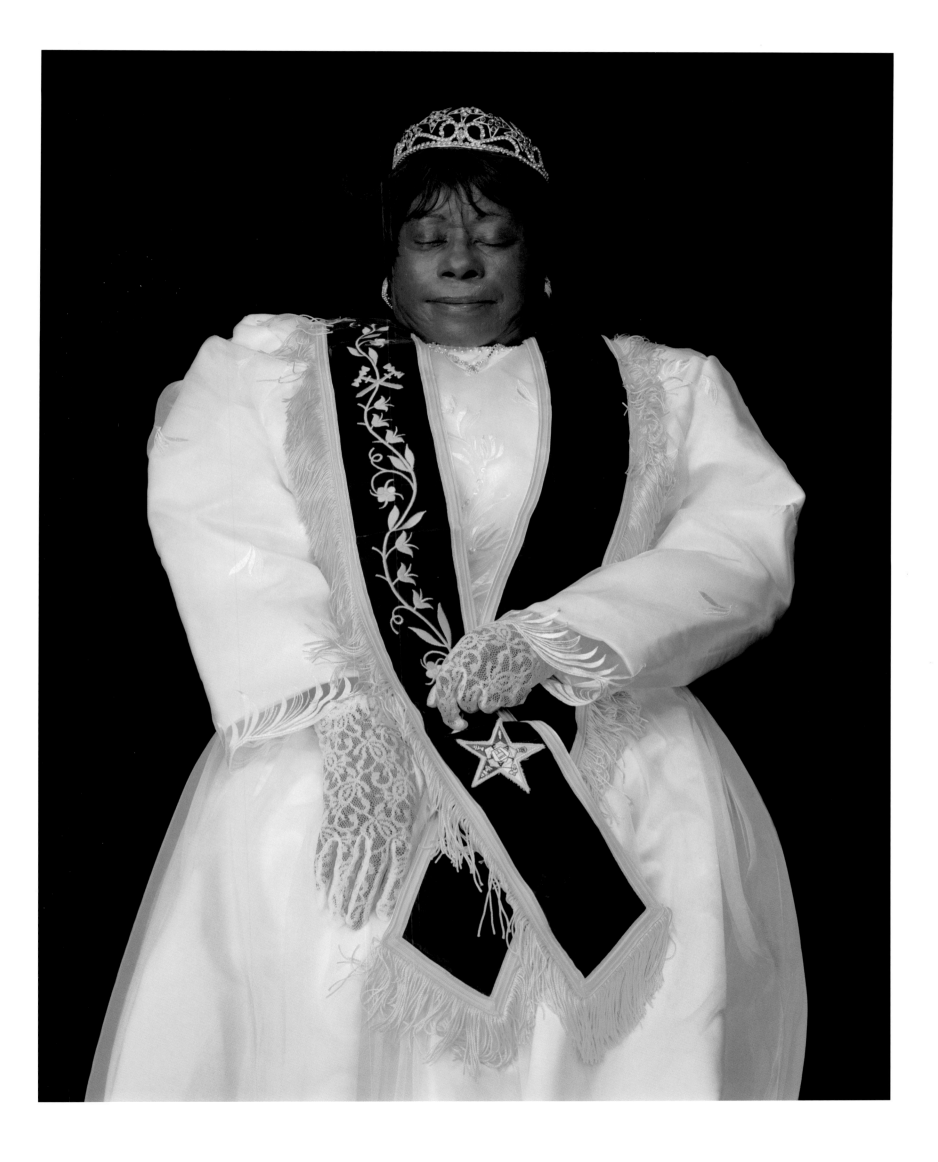

Nina Richards
Born: June 1915
Goldsboro, North Carolina
Died: September 2003
Harlem, New York

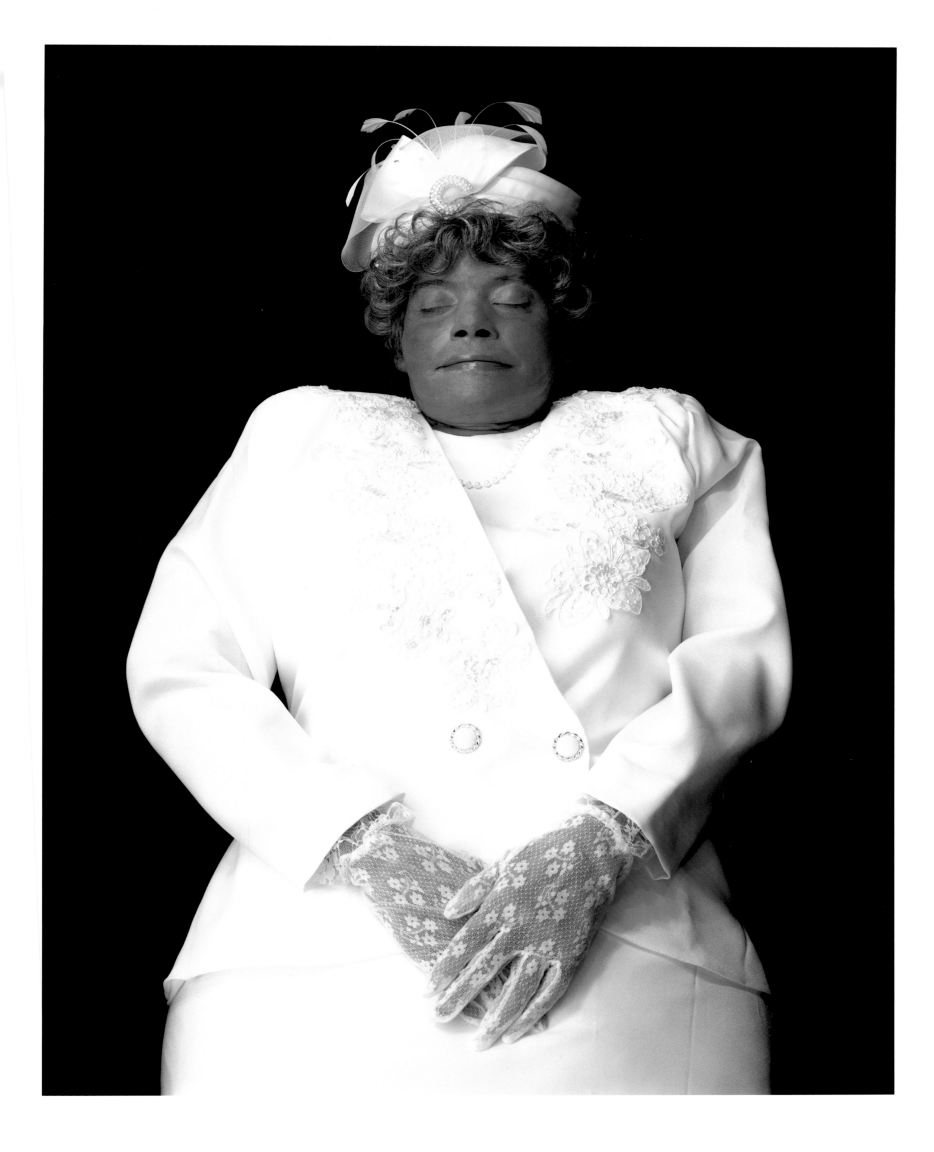

John Pershing Gore
Born: June 1920
Spartenburg, South Carolina
Died: July 2003
Harlem, New York

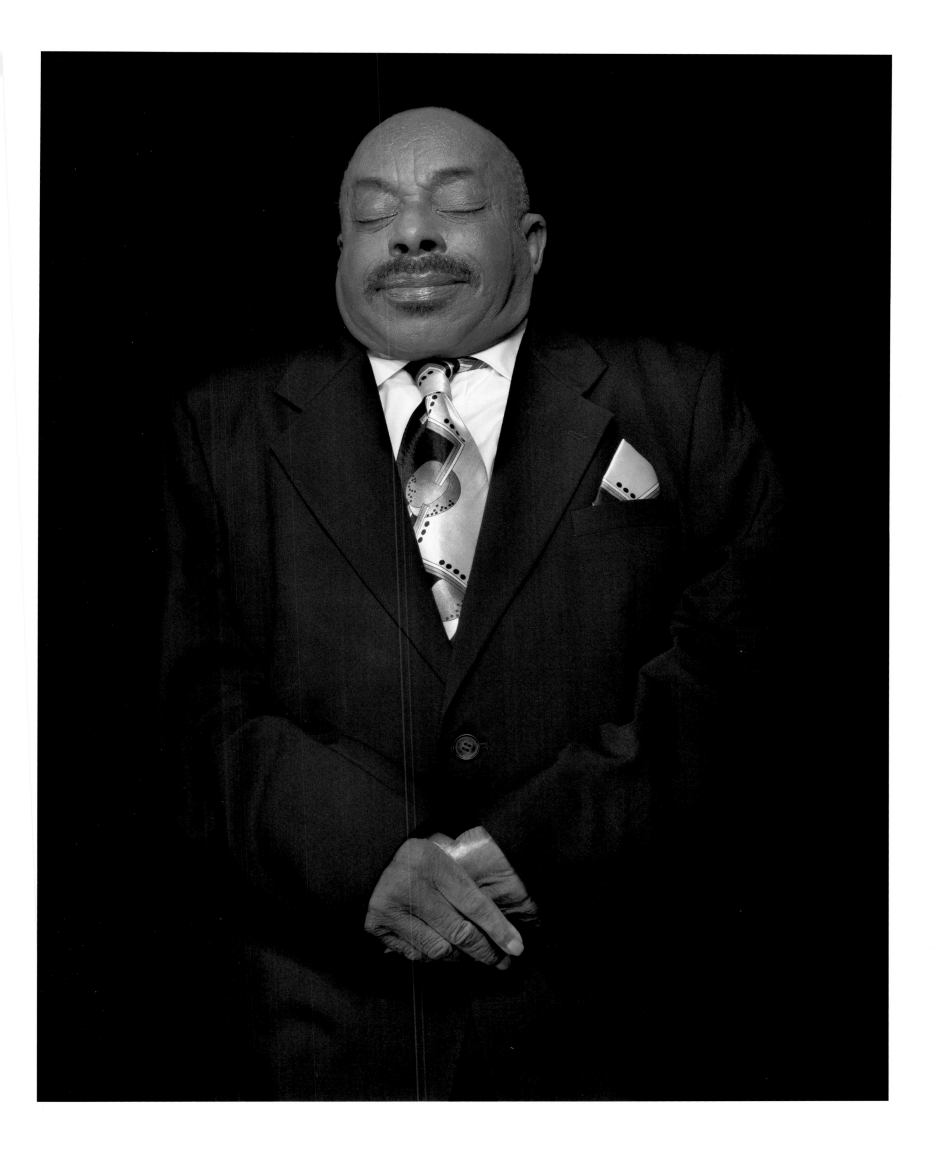

Thelma Azalea Sweat
Born: April 1912
Nansemond County, Virginia
Died: September 2003
Harlem, New York

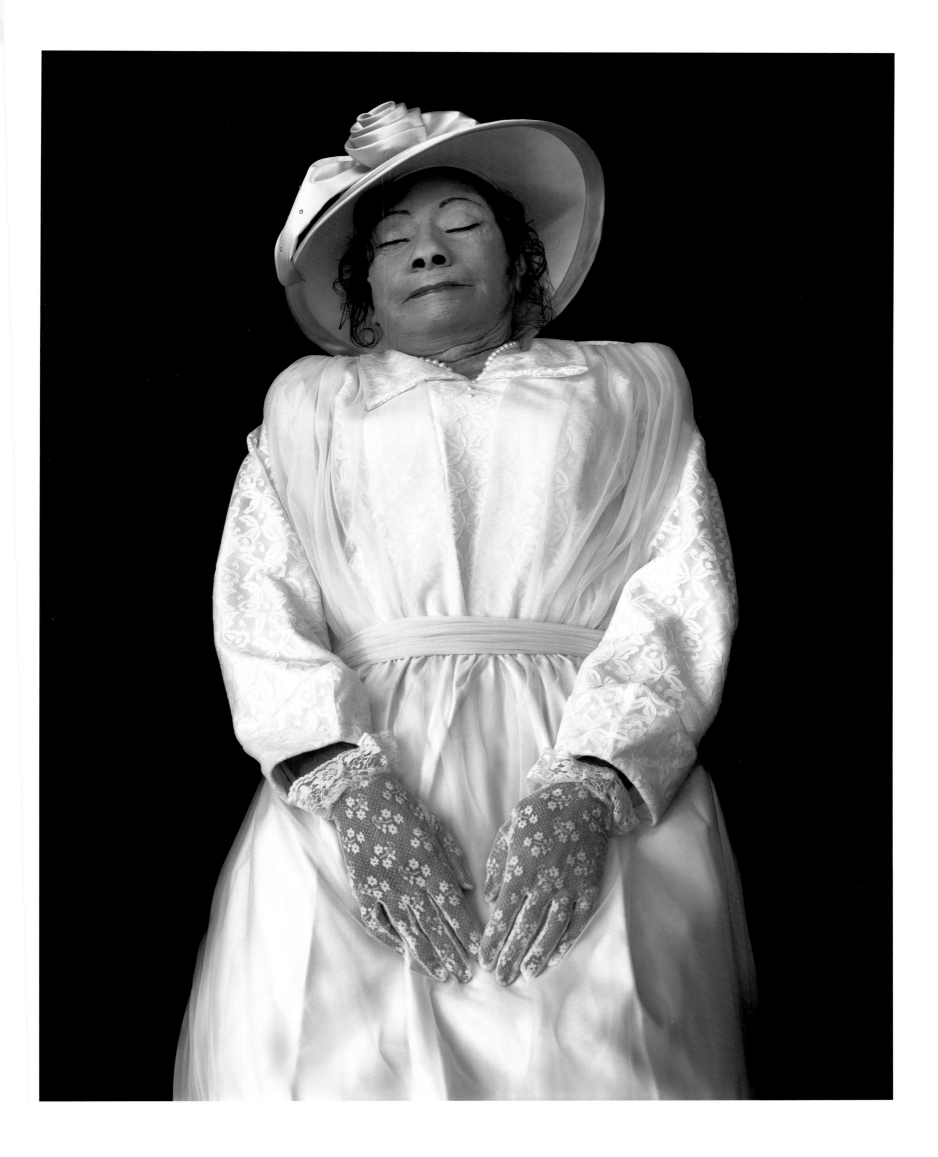

Willie Maddox
Born: July 1914
Atlanta, Georgia
Died: September 2003
Harlem, New York

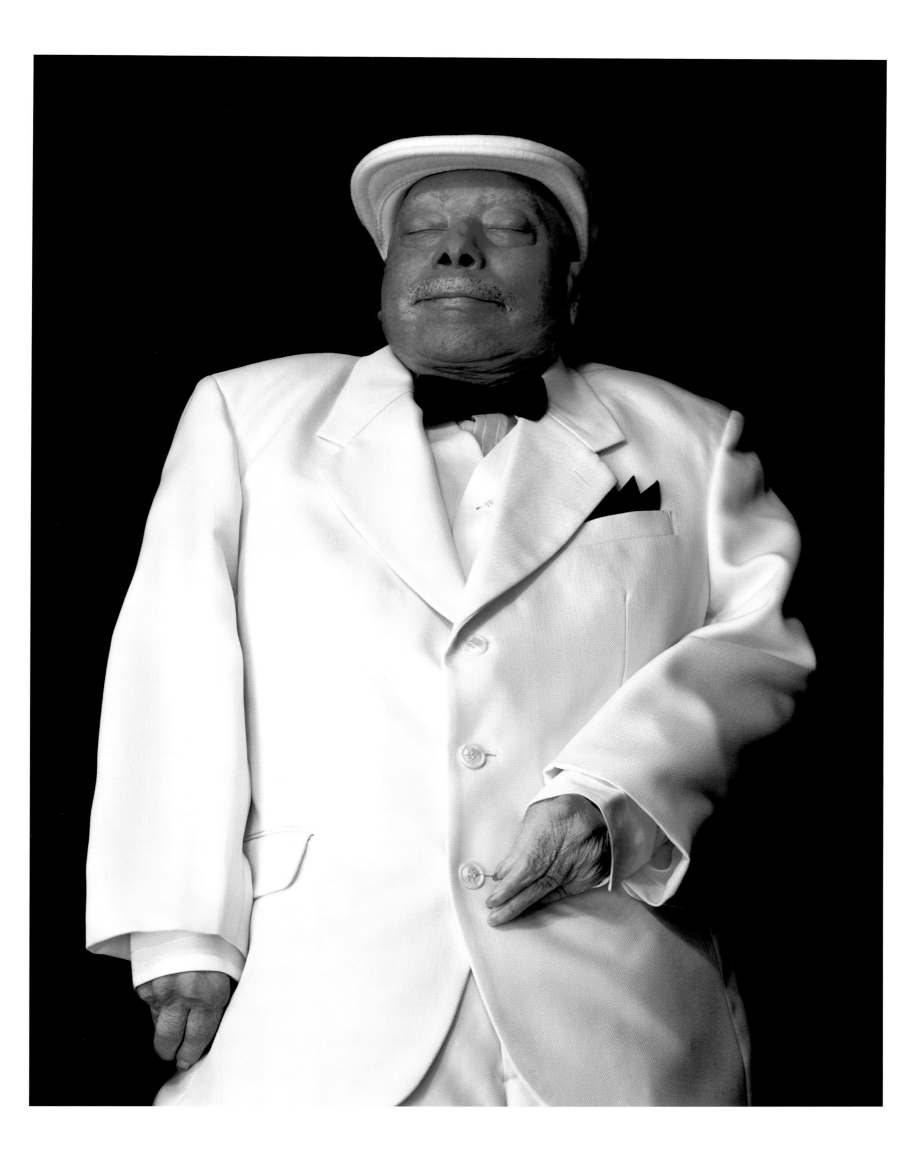

Margaret Alston
Born: January 1932
New York, New York
Died: August 2003
Harlem, New York

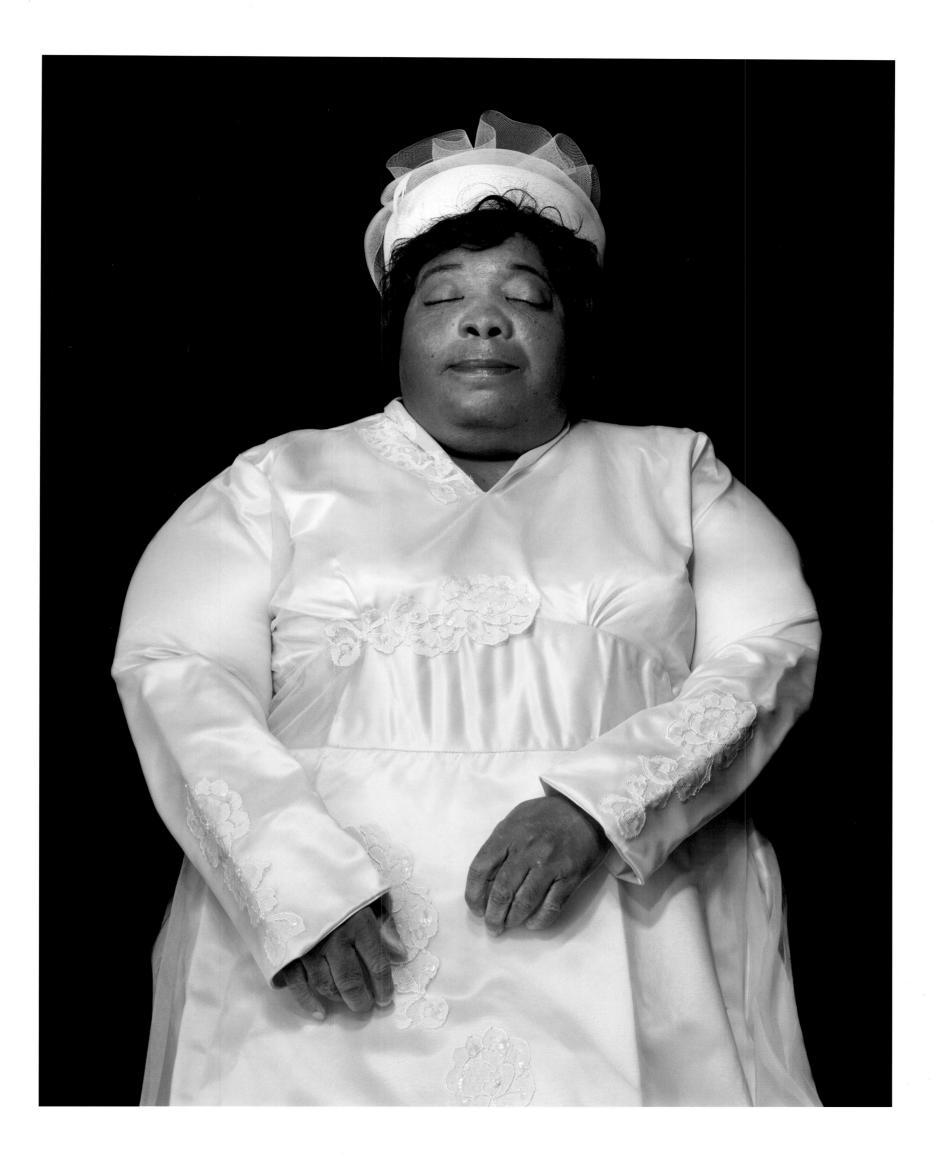

James H. Greene
Born: August 1937
New York, New York
Died: September 2003
Harlem, New York

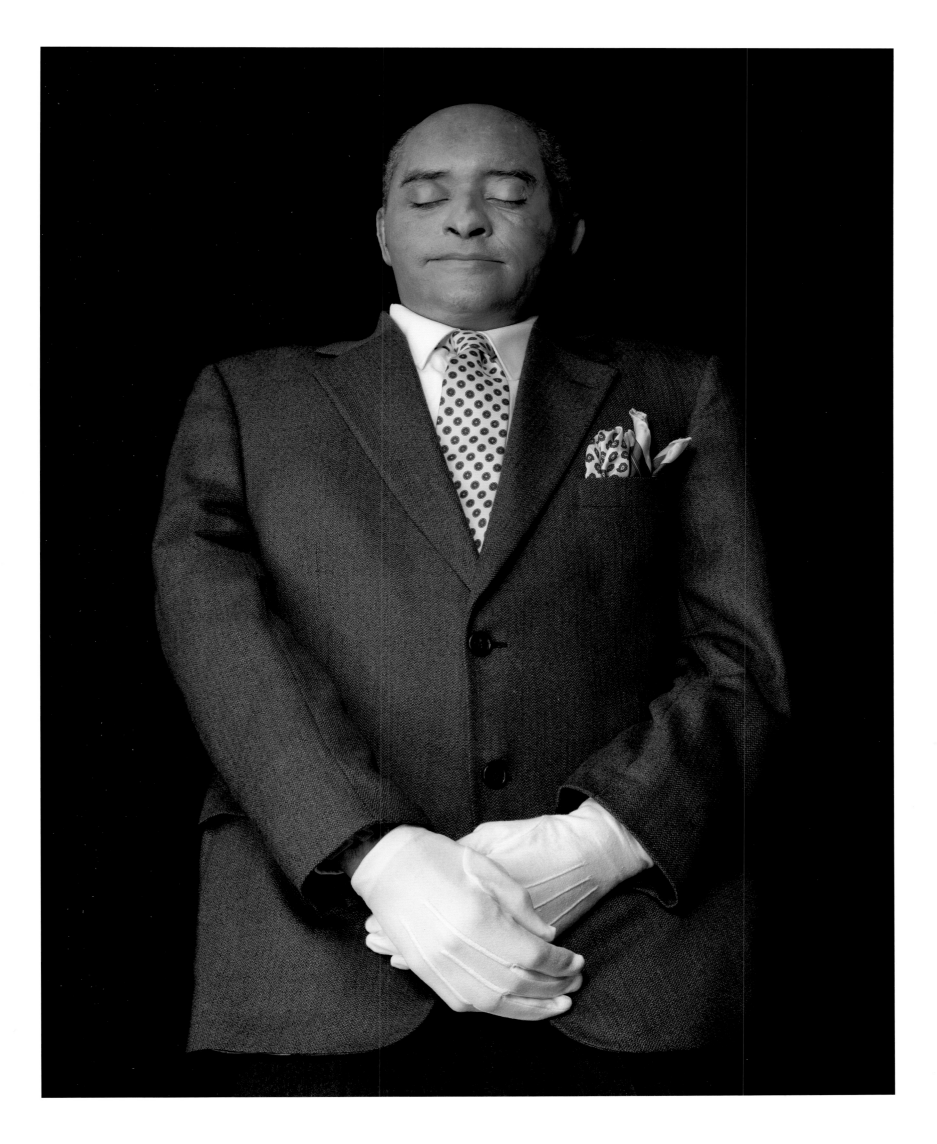

Margaret Forrest
Born: May 1902
Savannah, Georgia
Died: March 2003
Harlem, New York

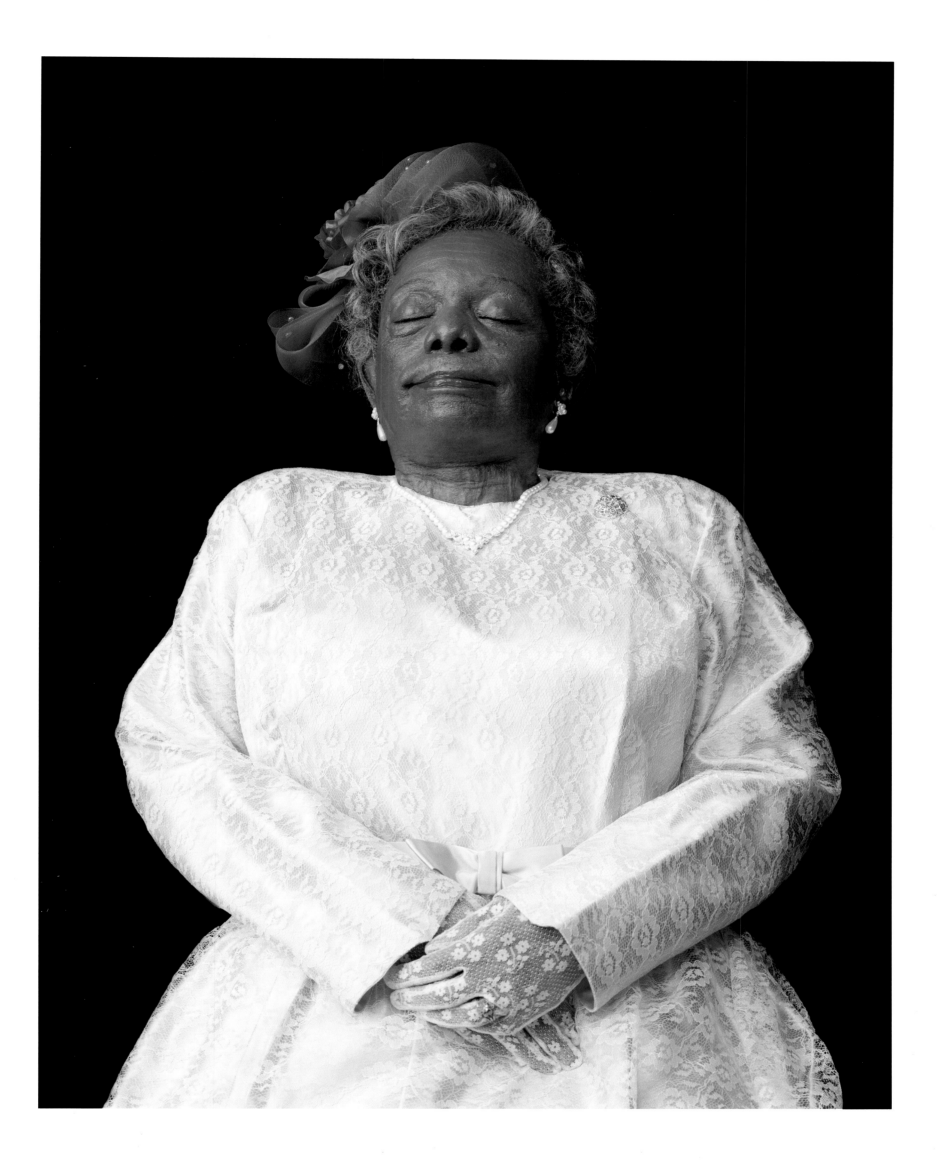

Viola Lovely
Born: March 1915
Warrenton, North Carolina
Died: January 2004
Harlem, New York

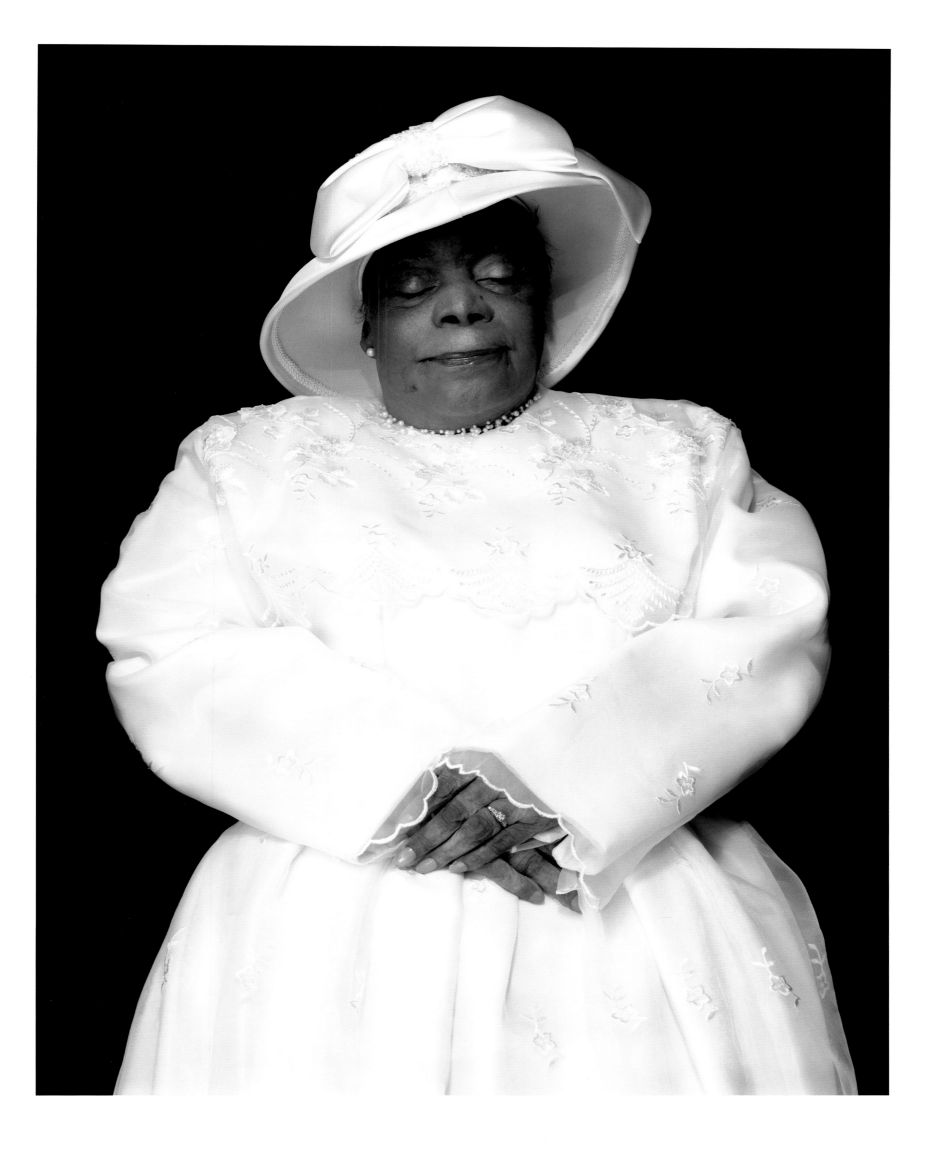

Joel Goff
Born: April 1950
Bronx, New York
Died: November 2003
Harlem, New York

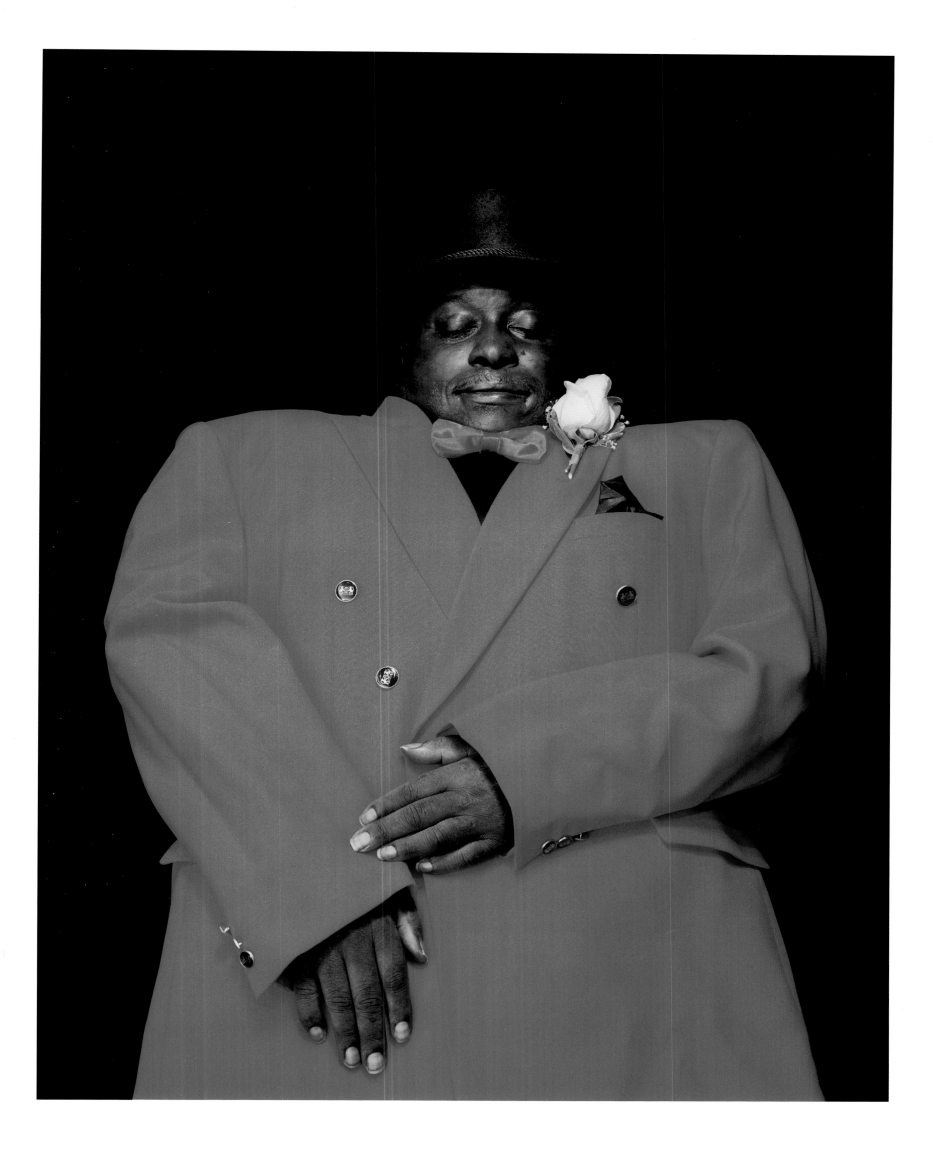

The Travelers
In Conversation: Elizabeth Heyert and Stacey D'Erasmo

How did this project begin?

I saw an article in the paper about a funeral director in Harlem named Isaiah Owens who did this old-style, Southern Baptist, traditional burial in which people were dressed up to be prepared to enter paradise. So I went up to Harlem. There was a woman named Betty Edwards in an elaborate coffin lined with white satin. She was in a big white hat, a white suit and she looked amazingly beautiful. She had a round face, a sweet expression. I was so moved by the idea of death being an occasion for which you'd put on your finest. I took a black and white picture, but it was simply a record of somebody in a coffin. It was a façade, and I had thought I was interested in that after doing my last project, *The Sleepers*, which was so much about the interior. But I kept looking and looking at the image; it was as if she was surrounded by all this stuff that shouldn't be there: the elaborate coffin, the quilted satin pillow, the flower arrangements. I thought it would be so wonderful to stand her up, light her well. I lived with the image for three weeks, working on the Polaroid with a magic marker, thinking that there must be a way I could do this.

What happened with the second person you photographed?

I phoned Owens and told him about my idea. He told me about someone, Margaret Forrest, who had just died at 101. I went up to the funeral parlor. She was so beautiful you can't imagine, all in pink with a fabulous purple hat. I asked as much as I could about her, tried to learn her story. Then we tried propping up the coffin on the platform where people deliver eulogies and it actually worked. I brought a large dark cloth to place under the body, then kind of taped up the cloth on the furniture and stacked hymnals on top to hold it down. I didn't understand yet exactly what I would need to do to make a real portrait. But once I took her away from the elaborate trappings, it was as if I knew her. I could see who she was.

As I looked through the ground glass, I got completely choked up. It stopped being about death and became about her whole life. A portrait is always about the coming together of two people, and that's what happened with her. It didn't seem like she wasn't there anymore, or as if I was looking at a façade. I could feel her humanity. I was just shaking and filled with excitement. I decided then that I wanted to photograph a whole community, a community of the dead.

How long did the project take?

From February 9, 2003 to March 14, 2004.

What was the actual process?

I used an 8 x 10 Deardorff, and shot three different kinds of 8 x 10 inch sheet film: color slides, color negatives, and black and white. With each person I knew I wouldn't have a second chance. I felt that I was recording history. I wanted to make sure I had whatever I might need to print the photograph. We brought one studio light, and then used a 60's arc light that we found there, and some fill cards to try to overpower the weird mixture of ambient light. It was difficult to do the sort of beautiful portrait lighting I wanted to do, because the funeral parlor had fluorescent lights and pinkish spotlights. Each shoot took about three hours, and the exposures were up to eight minutes long. Usually it was in the very early morning, because the family would gather the night before to see what their loved one looked like after the body was prepared by Owens, and approve. We'd get permission, get the release signed, and I'd get a phone call to be in Harlem in a few hours. The service would usually be at 10 a.m., so I'd go there at 5 or 6 a.m. and we'd work as fast as we could. In other words, we worked after the body was prepared for the service, but before being buried. There was a lot of time pressure. During the shoots, once someone was placed in the coffin over the black cloth I'd spend a lot of time manipulating the big camera. I was hanging over the body, high up on a ladder, always straddling a coffin with a big heavy lid. Then just before I took the photo, Owens would come in and I would direct him to delicately move the hands or head to create the most natural pose, do manually what I would usually explain to a living person who was sitting for a portrait. I never touched the bodies.

For a year I was perpetually on call. I never wanted to turn anyone down. I shot thirty-three portraits; there are thirty-one portraits in the project.

Were there any elements that recurred in these photos?

People here are dressed up for the journey to paradise. Owens called it "going to the party." The women wore these incredible hats and a number of them wore burial gowns which were satin, sequined, like prom gowns. In a number of cases, different women were in the same style dresses, but in different colors. Women sometimes wore the Eastern Star. Men often wore white suits. The men also wore hats; the men who were Masons wore fezzes. Jewelry was common; people would be buried in all their jewelry, like the Egyptians. Often, people would be prepared by Owens, the service would be held in Harlem, and then the dead would be flown back to the South, usually to one of the Carolinas.

Who is Isaiah Owens?

He's a very skillful funeral director who's been doing this since the '60s. He wanted to be a funeral director since he was very small; he started by burying matchsticks when he was five, then later, family animals when they died. He comes from Branchville, South Carolina, where he also has a funeral parlor. The parlor here in New York is a gorgeous brownstone on Lenox Avenue with a slogan on the awning: "Where Beauty Softens Your Grief." Outside the parlor are two stone benches. Engraved in one is "Sunrise" with the date of Owens' birth, and in the other is "Sunset" without a date. He pays a tremendous amount of attention to detail. He has a stock of burial gowns, pearls, lace gloves, hats; he wears white tie and tails and a top hat for the more elaborate funerals. He has a beautiful southern accent and wonderful turns of phrase. When somebody looks really great, for instance, he'll say, "Honey, she is a mess." He works all the time. He told me that undertaking has been one of the professions that African Americans could enter freely, because white people didn't want to bury black people.

We had endless conversations. We discussed religion constantly, values, hypocrisy, race relations. He told me many stories about the various people who died. Here are some of my notes:

"died of AIDS, 60 lbs."

"married for the first time in 2002"

"great-grandmother"

"food on sleeve—apparently he was known for spilling"

"of an elegant church lady: loved to gamble"

"school teacher"

"3 or 4 buses came from prison for her, because her whole family was in jail"

"splendidly dressed woman—had been in a coma for a long time, and her kids were fighting and fighting over her money. She woke up, called her lawyer, disinherited all the kids, and died the next day."

"woman in amazing big white hat (played the numbers). also: hair had to have a rinse before she was buried"

"friend of Owens, would always tell him, before she died, that when she died, someone was going to have to beat her wig the night before she was buried, meaning to sleep in it. As a very little girl, the daughter of a sharecropper, didn't have any shoes until she was six—church ladies bought her a pair of shoes so that she could be in the choir, because she had a wonderful singing voice—shoes were too small, but she was afraid to say anything. She had to walk to church, she finally got there, collapsed in tears from the pain, and they all said 'Hallelujah! She's seen the light.' Had her first child at 13."

In just the year that you were working there, did you see any changes in Harlem?

Yes, absolutely. It's changing so unbelievably fast. Now there's a Starbucks, MAC, Sports Authority, all the downtown chains. I saw a quintessential sign of the new Harlem on a restaurant blackboard: ham hocks and arugula salad. Four to five years ago when I went up to Harlem, it was all African American, and now it's many different types of people. Building is going on constantly, fancy condos and hotels.

How do you think your race influenced the way you took these pictures?

I was always an outsider, for so many different reasons. I'm white, born and raised in the North, not a Christian or a believer in any god. I didn't believe in the afterlife and I still don't, but I wish I did. It's a tremendously appealing belief. Owens would tease me, saying, "Elizabeth Heyert. She's not going to the party." I wasn't part of the Harlem community, not even slightly. As moved as I was, I was photographing

something from a tradition that was foreign to me, and I think my outsider status helped me do this. Owens and I had many conversations about preserving history. He seemed to find it surprising that someone from outside the community would want to preserve this tradition.

I think that race was part of what drew me in. These people, many of whom were from the South, were from such a different background from mine; their stories were profound to me. Many of them must have experienced a vicious racism that I had only read about. I'm a white American and I know how shameful that history is, and how much we still don't address it. Of course, this was a visual project, not an intellectual one, and if there was a funeral practice in Sicily or Japan that had this visual tradition, I might have gone there. But I wonder if I would have been as moved if it were in a foreign country. When I saw, say, that someone had been born on a plantation in the South in the '20s, I could imagine how far that person had traveled, the incredible distance. One man I photographed, for instance, was buried with an American flag. That's common for a veteran, but when I saw the dates, I knew that he must have been in the segregated army. That's shocking to me. But he and his family wanted to bury him with the flag. Only with the dead do you know the story from the beginning to the end.

I often thought that if any of these people had been alive, we couldn't have had this sort of intimacy. Maybe for an instant, if we could tear our guard down, forget centuries of history. But here, when I was looking through the camera, we could be intimate. As with *The Sleepers*, I felt that it was very important not to take advantage of this. In sleep or death you're so vulnerable. I knew I could get a lot of it wrong in these photographs, but I tried to get it right. I tried to get the stories and read the clues. I felt that it was a privilege. I hope that this is the opposite of sneaking into the morgue and taking pictures. The thing that struck me continually was the intense sense of a community from the past that didn't have a place in the new Harlem or really in the 21st century. It was an opportunity to photograph a community of the dead, and that was about culture, about race, about religion. I was always painfully aware that I was white. It was a much bigger factor than I had expected it to be.

During this year, you were always working between night and day, and with people who, in a way, really hadn't quite crossed over to the other side yet. How did that affect you?

I hesitate to say this for fear of sounding too girlish, but during the year that I was working on *The Travelers* I felt that, though I was always outside at the glass looking in, I was looking at a wonderful world. It was full of things I don't have: a big family, faith, traditions. Though there was the pain of not being able to share in it, I got to go into that world regularly.

But after I was done working in Harlem, it was like I was haunted. During the year of the project, I was almost unaware that what I was immersed in was about death. But afterwards, it was all about death. It was about everything about death that isn't beautiful. It was about decay, loss, and people being completely gone. I had nightmares. My creative project was over, but also this family, this community, though I was never a part of it. It reminded me of a Katherine Mansfield story I read when I was about twelve, about an old woman who goes to the park every day and sits on a bench. She sees a young couple who also comes there every day, and she watches them. This goes on for a year, until toward the end they catch her staring at them and the man makes a crack and she realizes that she's the quintessential outsider. It was similar with this. I was so aware of my outsider status, that I'd never be a part of the world I was photographing and never experience it again.

I see this as part of a trilogy: *The Sleepers*, *The Travelers*, and my next project. But I'd never want to photograph the dead again, because after it ended it became not about beauty and community and history, but only about death. I thought about doing more pictures, but I couldn't bring myself to do them. In fact, every single time after photographing someone, I thought, I can't go back, I can't do this. My two fears were that I'd never get to do another one and that I'd have to do another one.

Who was the last person you photographed?

A young man, only 22 years old. The first portrait I did was the oldest person, and the last one I did was the youngest. His name was James Earl Jones—his street name was Jay Moe. It was probably the hardest one emotionally. I had photographed his mother, Daphne Jones, less than a year before, and she was also quite young. He was buried in a brand new Sean John track suit and new Timberland boots. When I got there, he was in a coffin stuffed with CDs, money, his beads, and dozens of notes and photographs from his girlfriends, photos of his kids. It was a strange, modern twist on the idea of what you'll need in paradise after you die—the CDs, the money. It broke my heart. Even though he had died violently, that's less and

less the norm. The kids who buried him thought they were invulnerable; their notes said "See you soon!" and "I love you, baby." They were so young themselves that they didn't have any idea, really. His mother, too, had had such a tough life, but in death all of that fell away.

As you were working on the project, was there anything that you saw, out of the corner of your eye as it were, that you knew you couldn't get?

The truth was that it was technically so difficult to do it at all that sometimes I could make a lifelike photo, but sometimes I couldn't, depending on factors like how someone was embalmed or how sick the person had been. Usually when you take a portrait, it's not an accurate rendering or a document, it's a relationship, it's what's happening at that moment between us. It's me bringing all my experience and the other person bringing theirs. I was still bringing my experience and trying to understand the experience of the person in front of me. I was interpreting, making emotional decisions. With any portrait, what you choose to leave out is conscious; it can change everything. But my biggest regret was that I couldn't show the people the photos afterwards, to say, "Look what we did." That's what I could never do. I know it sounds ridiculous, but it always made me miserable three or four days after the shoots, when I'd realize that I couldn't call up the people and talk about the picture, as you normally would. I came in after the story was over.

How do these photographs fit into the tradition of memorial photography?

Memorial photography really follows the history of photography. Before photography, only rich people could have their portraits done. Photography was more egalitarian; everyone could have portraits. Memorial photography was especially popular in the 19th century, because so many children died. People wanted a record of their short lives. The children were propped up, looking alive. It was a different approach, more sentimental; it was popular to say things of the dead like, "She's just away." But it was also an opportunity for African Americans to create a view for themselves into history. Since the African American tradition was to dress up to be buried, it was a great time to do a portrait. With memorial photos, African Americans began a visual record that they hadn't had before. As medicines got better, though, people stopped taking these pictures. Now, very few people even have open coffins, much less memorial photos.

But, actually, I didn't think of what I did in Harlem as memorial photography at all. I was doing portraits of a community after death. I don't think of this as memorial photography, but as a series of portraits. My portraits aren't about death, but about people's lives. I'm interested in what makes up the essence of us as human beings and what the person outside sees. We have strong reactions to the people, not to the fact that they're dead. In a way it's always a portrait of the viewer: a white person will see something different than an African American person, a religious person will see something different than a non-religious person, and so on. They're not unlike eulogies: these photos are a visual version of what the living—the families, Owens, I—want to remember, the stories we all want to tell about the dead.

I thought quite a bit about the right size for these photos. They're 30 x 38 inches (76 x 97 cm), just slightly smaller than life size. I photographed James Patterson in February and in April his portrait was on a wall in a museum in Switzerland. Nothing in his life would have led him to expect that he might end up there. I felt that if I chose to make these images very big, it would sensationalize them. I didn't want to make them tiny, precious objects, either. These people will be seen—in galleries, in a book, on a wall in Switzerland—at an intimate and vulnerable moment. I felt a great responsibility there, to present these people in the right light for this part of their journey.

What story do you think you were telling with this project?

It's complicated. In part it was the whole idea of a community that has vanished. They're gone, but so is the world they came from. These people all came from different places and they'd all made this journey, not only from the South but sometimes from great oppression, to Harlem, where they had more chance to be who they wanted to be. The story I was trying to tell is that this is the way they were. This was the 20th century journey.

"The Travelers, 2003–2004," is a series of thirty-one photographic portraits of the dead. Each image is a chromogenic color print, 30 x 38 inches (76 x 97 cm), printed in an edition of six. The works were photographed in Harlem, New York, and first shown at the Edwynn Houk Gallery, New York, in June 2005. Original color photographs were printed by Anthony Accardi, Green Rhino Inc., New York.

Elizabeth Heyert is the author/photographer of *Metropolitan Places*, *The Glass-house Years*, and *The Sleepers*. Her photographs are part of the permanent collections of the Metropolitan Museum of Art, the San Francisco Museum of Modern Art, as well as numerous private collections, and have been extensively published and exhibited internationally. Heyert lives in New York City.

Stacey D'Erasmo is the author of the novels *Tea* (Algonquin, 2000) and *A Seahorse Year* (Houghton Mifflin, 2004).

Elizabeth Heyert
The Travelers

Editorial assistance: Teresa Go
Book design: Katharina Blanke/Scalo
Scans: Art-D, Prague
Printing: Trico, Prague

© 2006 Elizabeth Heyert Studios, Inc.
© 2006 for this edition: Scalo Verlag AG

Scalo head office:
Scalo Verlag AG
Schifflände 32, CH-8001 Zurich, PO Box 73 CH-8024 Zurich, Switzerland
tel: +41 44 261 0910, fax: +41 44 261 9262
publishers@scalo.com, www.scalo.com

Distributed in North America by Prestel, New York; in Europe, Africa, and Asia by Thames and Hudson, London; in Germany, Austria, and Switzerland by Scalo.

First Scalo Edition
ISBN 3-908247-93-4
Printed in Czech Republic